GWR LOCOMOTIVES
THE PRAIRIES

ALLEN JACKSON

AMBERLEY

First published 2022

Amberley Publishing
The Hill, Stroud,
Gloucestershire, GL5 4EP

www.amberley-books.com

ISBN: 978 1 3981 0963 6 (print)
ISBN: 978 1 3981 0964 3 (ebook)

British Library Cataloguing in Publication Data.
A catalogue record for this book is available from the British Library.

Typeset in 9.5pt on 12pt Celeste.
Typesetting by SJmagic DESIGN SERVICES, India.
Printed in the UK.

Contents

Preface 4

1 The Large Prairies 5
The 3100, 5101, 61XX, 81XX and 3150 Classes 5

2 The Small Prairies 7
The 44XX, 45XX and 4575 Classes 7

3 The Dean/Churchward Prairies 8
The 39XX (3901) Class Dean/Churchward Design 8

4 Allocation and Work 9
Table of Historic Workings and Movements 11
Index of Maps Used for the Table 53
Maps Depicting Prairie Working Locations Across the GWR Network 54

5 The Prairie Gallery 67

Table of References Used Throughout the Book 89

Glossary of Terms and Abbreviations 95

Preface

Much has been written about GWR locomotives over the years, but this book uses the novel approach of the compilation of a table of over 1,030 entries detailing the places and work undertaken by the locomotives. These table entries are then plotted on a series of twenty-one maps of the GWR, some of which ceased to exist fifty-plus years ago. This book is a unique resource.

Engines of companies absorbed by the GWR are not covered; for example, the Alexandra Docks prairies and the Vale of Rheidol, later Cambrian, narrow-gauge prairie tanks are omitted.

Some previously unpublished photographs have been used with the help of Laurence Waters, a noted historian and author at the Great Western Trust, Didcot Railway Centre.

Although personnel are generally referred to by the male gender, because in history that is what they were, it is recognised that many crews and operating staff on the heritage scene are not all men and they are carrying out valuable work in helping to keep the railway history of this country alive.

The Prairie locomotives are dealt with in the order of their first appearance.

1

The Large Prairies

The 3100, 5101, 61XX, 81XX and 3150 Classes

In 1903 Churchward produced the first of what was to be a classic GWR two-cylinder standard design, which was to be constructed up until 1949 after the GWR had ceased to exist. Although primarily constructed for suburban passenger work, they were equally suited to freight, express passenger and banking duties.

The first, No. 99, was smaller and lighter than later engines with flat-topped tanks, no top feed and the brass number plate secured to the tank sides, which, together with the tank underneath the bunker, totalled 1,380 gallons – in later engines, with larger side tanks and bunker, it was 2,000 gallons. It was a test engine for two years and a number of modifications were made to subsequent engines in the light of trials.

The history of the locos over nearly fifty years of construction is complex but has been summarised in the table below. There was an experiment with two-way water scoops for troughs, but this was not extended to all classes. The RCTS books on the subject listed in the references section lists already published minute detail material.

MM/YY (19)	1st Number	2nd Number	3rd Number	Driving Wheel Diameter	Boiler Pressure	Route Colour & Power
9/03	99	3100	5100	5' 8"	195 psi	D
01/05 – 06/05	3111-30	5111-30	31XX Class	5' 8"	195 psi	D
01/06 – 03/06	3131-49	5131-49		5' 8"	195 psi	D
04/06	3150			5' 8"	200 psi	D
04/07 – 01/08	3151-90			5' 8"	200 psi	D
11/29 – 12/30	5101-74	5101 Class		5' 8"	200 psi	D
01/31 – 11/34	5175-99			5' 8"	200 psi	D

08/35-12/49	4100-79			5' 8"	200 psi	D
04/31 – 11/35	6100-69	*61XX Class*		5' 8" 6116 5' 3"	225 psi	D
09/38 – 11/39	8100-09	*81XX Class*		5' 6"	225 psi	D
12/38 – 10/39	3100-04	*3100 of 1938*		5' 3"	225 psi	D

All Large Prairies were BR Power Classification – 4MT

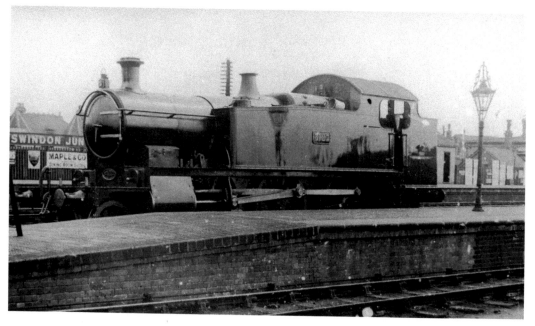

3127 in original condition at Swindon Junction station, 1905. The features include square drop footplate, small boiler with no top feed and tall safety valve cover, number plate on tank sides, works plate on smokebox saddle, small bunker and tanks, swan-necked front vacuum pipe, toolbox on footplate above cylinder, and no bunker steps or smokebox struts. MAP C. (Great Western Trust)

The Small Prairies

The 44XX, 45XX and 4575 Classes

Churchward produced another success with these relatively small locomotives that were suited to steep gradients and sharp curves as well as heavy loads. Charles Collett improved and expanded the class with another 100 engines, starting with 4575. The Cheltenham Spa Express (Cheltenham Flyer) was hauled by a member of the 45XX/4575 Class from Cheltenham to Gloucester and portions of the Cambrian and Pembroke Coast expresses were similarly entrusted with the headboard.

MM/YY (19)	1st Number	2nd Number	Water Capacity	Driving Wheel Diameter	Boiler Pressure	Route Colour & Power
10/04	115	4400	1000 gallons	4' 1½"	165 psi	B
07/05 – 06/06	3101-10	4401-10	1000 gallons	4' 1½"	165 psi	B/C*
10/06 – 03/10	2161-90	4500-29	1000 gallons	4' 7½"	180 psi	C
04-13 – 11/24	4530-74		1000 gallons	4' 7½"	180 psi	C
02/27- 02/29	4575 - 5574		1300 gallons	4' 7½"	180 psi	C
44XX Class with 16½-inch cylinders were power class B, uncoloured; those with 17-inch cylinders were power class C uncoloured.						
All later small Prairies were BR Power Classification – 3MT						

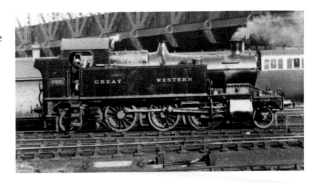

4521 is at rest at Scrub's Lane Bridge near to Old Oak Common awaiting its next turn of carriage shunting. This class spent only a few years on this task and were moved out in favour of the 57XX pannier tanks. All prairies were lever reverse, which made shunting easier. The scene dates to around 1928. Map A. (Great Western Trust)

3

The Dean/Churchward Prairies

The 39XX (3901) Class Dean/Churchward Design

The Metro and 517 Class engines of Joseph Armstrong dating from the 1860s were very highly regarded by his predecessor, William Dean, but as suburban traffic loads became heavier with the popularity of living close to the countryside around London and Birmingham, a more powerful replacement was sought; however, the large Prairies, which were to be the ultimate solution, were not yet ready in sufficient numbers.

It was in 1907 at Swindon, the works operating at full tilt, that Churchward modified some of the Dean Goods engines.

In his typical pragmatic style, Churchward took the current favourite, the free steaming Dean Goods 0-6-0 tender engine, and did away with the tender, bolting a pair of tanks on the side and a pair of pony trucks each end to assist with weight distribution and driving wheel flange-wear. The frames were new, to accommodate pony trucks at both ends, but the motion and wheels were original. The boiler was the No. 5 standard, as used on the small 45XX Prairies.

The GWR opened the North Warwickshire line, as an adjunct to Birmingham suburban services in 1908, and the 39XX Class appeared at Tyseley mostly for these duties.

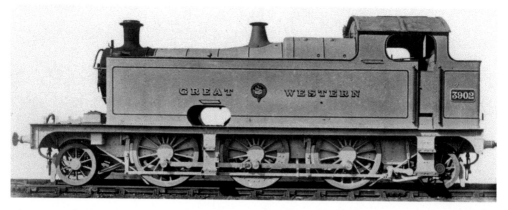

3902 is in as-built condition and Swindon Works photographic grey with the garter crest insignia in 1907. The loco has a short bunker, no top feed and no housing protruding from the footplate beneath the smokebox, which housed the springing for the front pony truck. Map C82. (Great Western Trust)

4

Allocation and Work

The following table is a selection of Prairie workings together with shed and works events over their working lives and has been compiled from various publications, whose reference is to be found towards the end of the book. It should provide a record for modellers and those interested in the doings and locations of particular class members. It is fascinating to follow the movement of engines around the system as traffic patterns changed or the railway routes reduced or became modernised.

A series of maps in the book contain references to the tables so that you can see where a particular location is and on what line. The maps are neither to scale nor necessarily to proportion but illustrate where some of the more out of the way places are in relation to the major centres.

The tracks are coloured in accordance with the GWR's route availability colours, except uncoloured is shown in black.

The King Class double-red routes are not defined, but dotted routes where locos of that colour may proceed though at reduced speed specified for the line in question. All lower weight colours could travel at the normal line speed – whatever that was.

For reasons of clarity and space, not all lines or stations are shown on all maps. The table of map contents follows the text table.

Each reference on a map also contains the locomotive's number so that you can choose a location and then see what locomotives have a table entry for that place.

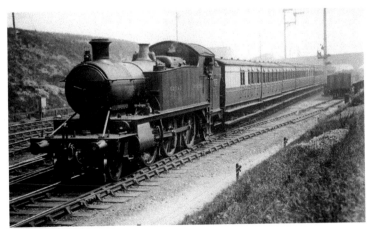

51XX Class 5138 is pictured near Hatton with a Birmingham to Leamington Spa train in around 1922. The train would appear to be comprised entirely of Dean six-wheel coaches. MAP MD. (Great Western Trust)

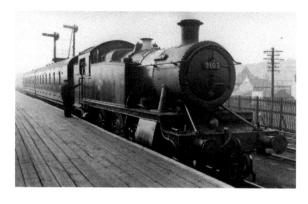

3103 (3155 until August 1939) waits at Platform 4 at the GWR/LNWR joint station of Brynmawr on the former Methyr, Tredegar & Abergavenny Railway lines with a train from Newport. The signals in the background are LNWR examples. Around 1958. MAP K. (Great Western Trust)

This is in addition to the photographs and captions that adorn the book throughout, but here each caption is given a map reference letter, where it is known. Other historical detail is included where it is thought to be of general interest. Most of the books are long out of print, but are often available on internet auction web sites.

Where a precise date or location is unknown or best guessed it will be shown as, for example, ??/6/59 or ?Abergwyfi. Similarly, train make-ups are not always completely visible in a photograph, so '?' will be used where there is any doubt.

In order to maximise the amount of information for each table entry, abbreviations have been used – please consult the listing at the end of this book if required. In addition, some punctuation has been omitted from table entries to save space in addition to station name punctuation, which was frequently omitted on the original Act of Parliament.

Train make-ups are GWR headcodes of A – Express Passenger; B – Stopping Passenger; C – Parcels; D – Fitted Freight, Empty Stock; E – Express Fish; F – Through Fast Freight; G – Light Engine or 'branch' passenger; H – Mineral, Ballast or Empties; J – Through Freight Pickup; and K – Pickup Goods. In addition, there is R – Royal Train; Pilot – pilot at the head of the train or banker; and Tail – tail lamp displayed only. Many local passenger trains would have the G code where the fireman would place the lamp on the footplate rather than climb up to place it by the chimney as a B code. So, for G read B in some cases. G code was also officially used for auto-trailers and some examples occur in the book.

Where a dash is placed in the headcode column it means either the locomotive is not displaying a headcode or the angle of the photograph of the subject means it cannot be seen. In some cases the loco is displaying an inappropriate headcode for the train make-up.

Where Anglicised Parliamentary versions of Welsh place names were used historically for station names, the Welsh language version follows in brackets.

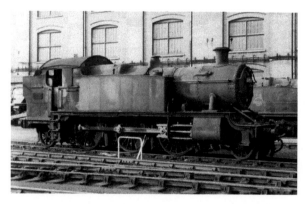

3150 is seen here at Swindon works in around 1955 and by this time the engine looks like a final variant and was withdrawn from service in September 1957 after over fifty-one years of work. 86E shed plate, although its final depot was Stourbridge Junction. Zooming in, the 'G' of the GWR 1942 lettering style can be seen. This engine had originally been fitted with two-way water scoops. MAP C. (Great Western Trust)

Table of Historic Workings and Movements

No	Head Code	Location and Detail	Date dd/mm/yy	Map Ref	Book Ref
3100	-	Works photograph of original No 99, Small tanks and bunker, no top feed, small boiler	??/09/03	C02	GST
3100	-	Works photograph, rebuild of 3173, 3150 class, smaller driving wheels	??/09/38	C03	GST
3100	B	Cardiff General bay platform, Porthcawl, ?4 coaches, 86E shedplate	??/08/51	K01	CL
3100	-	Swindon works dump for scrapping	08/12/58	C04	BIR
3101	B	Stratford-upon-Avon shed ½ in/out over pit	21/04/57	MD09	G16
3102	K	Wolverhampton goods yard, Wrexham, ?20+ mineral wagons	20/07/54	M10	BIR
3112	B	Severn & Wye excursion, clerestory coaches, ?Ebbw Vale/Newport origin	??/??/12	K02	G86
3117	-	Old Oak Common coal stage, brake gear rigged outside front and centre drivers	??/??/23	A01	G86
3119	B	Bath Spa, clerestory coach, running in turn ex-Swindon, Newport/Cardiff allocated	??/??/07	D64	G86
3120	-	Swindon Photographic grey livery, newly allocated, two-way water scoop drawing	??/02/05	C05	G86 APR1
3121	-	Westbourne Park shed yard, worksplate between cylinders, no top feed, portholes	??/?6/05	A02	G86
3128	C	Reading mixed parcels, horsebox, FRUIT, CORDON, coaches	??/??/27	C83	APR1
3131	-	Old Oak Common near lifting shop, 1927 livery, bunker lamp recess/fender	??/??/28	A03	G86
3132	K	Exeter shed outside, Garter crest, top feed, numberplate on bunker, smokebox stays	??/??/12	F01	G86
3141	-	?Newport, Garter crest, toolbox above cylinder, bunker extended	??/??/13	K03	G86
3141	B	Reading platform, ?Reading-Paddington, parcels van, Slough allocated	??/??/21	C06	G86
3141	-	Slough goods yard, light engine, GREAT WESTERN lettering, no crest	??/??/22	B48	G86
3142	B	Bentley Heath, Close coupled 4-wheel 7 coaches, brake with side tail light	??/?5/27	M11	GW1
3146	-	Old Oak Common, coal stage in background, two 43XX 2-6-0 marshalled behind	??/??/30	A04	ZEN
3150	B	Platform 6 Paddington, clerestory and other coaches	??/??/1?	A05	CL
3150	Pilot	Near Aller Junction, 5002 Ludlow Castle, ?10 coaches	??/??/31	F02	ZEN
3151	B	Rushey Platt, staged photo of Birmingham four coach set, panelled 1922 livery	12/10/24	C80	GWW
3152	J	Totnes down platform, banking duties light engine, No 3 Target	10/07/34	F03	GWV
3159	Pilot	Near Pilning stn. loaded coal train, 28XX, target pilot disc no 4	??/?3/36	DS01	W30
3160	B	Paddington, platform 6, clerestory coaches, horse drawn and motor carts, cabs	??/??/07	A38	CL
3164	Pilot	Sapperton Tunnel, 11.35 Cheltenham-Paddington, 7006 Lydford Castle, A	??/03/51	C07	CL
3164	G	Banking freight up towards Sapperton Tunnel, TOAD with side lamps	03/03/53	C08	CL
3168	-	Tyseley shed works, under repair	??/??/10	M12	150G
3170	K	Newport High Street centre road, minerals 16T and 20T, general opens and vans	??/??/51	K04	LBR
3170	F	Newport High Street centre road, eastbound	??/01/58	K05	GW5
3174	Pilot	Eastern Severn Tunnel, 5243, coal, coke,	??/??/35	DS02	W30

		covered vans, pilot engine target disc			
3176	B	Near Warwick, 10 coach Leamington-Birmingham	??/??/30	MD13	GW2
3176	Pilot	Near Patchway station banking coal train with tunnel TOAD +TOAD	??/?3/36	DS03	W30
3176	Pilot	Severn Tunnel, Bulldog 3392 New Zealand, parcels, MINKS, coaches, SIPHON, pilot disc	??/?3/36	DS04	W30
3184	Pilot	Near Dainton Tunnel, 5008 Raglan Castle A, Only 5 coaches visible	??/??/29	F61	ZEN
3185	B	Birmingham, local, Dean coaches	??/??/1?	M14	GW1
3186	G	Aller Junction, Kingswear, 7 mixed coaches	17/05/36	F04	GWV
4100	B	Toddington platform, 11.35 am Cheltenham-Honeybourne, 2 coaches, taking water	26/04/58	J01	GBLG
4100	-	Stroud bay platform end, coupled ?B set, two loco-spotters in cab	??/03/61	J02	WSF
4100	B	Gloucester Central platform, Hereford train, 4 coaches, loco modern green livery	13/04/62	J03	WGW
4100	B	Chipping Norton platform, from Kingham, 2 coaches, 1 Hawkesworth	19/05/62	I01	MGW
4100	B	Near Weston-under-Penyard Halt, 10.25 am Hereford Gloucester service.	21/12/63	J04	WGW
4101	B	Kingham platform, 2 coaches, Cheltenham 11.18 am	??/05/62	I02	GWY2
4101	G	Chipping Norton, run round stock, pulling into platform from tunnel for Kingham	02/07/62	I03	GDG
4101	-	Oxford shed, 2D shedplate, Banbury	??/10/63	I04	GWM3
4102	B	Carrog up platform, 4 coaches	??/??/5?	P30	RTB
4103	B	Saltney 08.35 Snow Hill to Chester	??/?6/54	Q01	SWC
4103	-	Taunton station pilot, taking water platform	14/04/62	E01	GW5
4103	A	Congresbury platform, Cheddar Valley + 6148, Home Counties Railway Society	09/10/63	D01	GSS
4103	K	Clutton, loaded coal train from Radstock ?15 wagons	30/04/64	D02	GW1
4104	B	Acocks Green platform, Snow Hill-Lapworth, lunchtime shoppers on platform	??/08/56	M15	TFL
4104	B	Buildwas platform, 8.15 am Shrewsbury-Kidderminster	??/??/57	N03	WML
4104	K	Brimscombe shed, Sapperton bankers with 4100 both Gloucester Horton Road shed	??/04/63	C09	SCP
4105	B	Crewe stn, Shrewsbury, ?5 coaches, LMS & GWR, LMS 2-6-4T 2617 background + train	13/09/47	Q02	TRI
4105	B	Burnt Mill Sidings, Shrewsbury, Severn Valley train	??/?6/54	N04 DET	RCS
4105	B	Near Sutton Bridge Junction, Kidderminster-Shrewsbury, ?4 coaches, carriage shed	??/??/54	N05 DET	SAR
4105	-	Bicester North Yard, damaged by runaway train near Bicester, condemned Feb '64	23/12/64	I05	100
4106	-	Leamington platform, Snow Hill-Leamington, TYS on cylinder top, LMS signals behind	04/08/51	MD16	G58
4107	F	Standish Junction, Swindon, minerals and army lorries, ?30 wagons	20/07/63	J05	WES
4107	G	Longhope platform, ?2 coaches, single line token apparatus	04/04/64	J06	ABL
4107	K	Gloucester Central platform, Hereford train	27/06/64	J07	WGW
4107	B	Grange Court Junction stn. Last day of Hereford- Gloucester service	02/11/64	J08	WGW
4109	B	Teignmouth sea wall, Newton Abbot-Exeter, ?3 coaches GWR livery	23/02/51	F05	GDG
4109	-	Chipping Norton main platform, 4.35 pm	04/11/61	I06	NOS

		Kingham, 2 coaches			
4109	-	Gloucester Central down platform, light engine, Gloucester allocated	19/10/63	J09	G76
4110	K	Tyseley shed yard, with 57XX pannier tank, 4110 1934 livery	12/06/37	M17	G91
4110	G	Buildwas stn, Severn Valley train, mixed coaches	??/07/47	N06	WMI
4110	B	Henley-in-Arden platform, Moor Street-Stratford	??/11/58	MD18	G11
4111	B	Snow Hill centre roads, light engine, backing signal off	??/??/47	M19	G101
4111	-	Tyseley coal stage, lined green livery	16/06/57	M20	BIR
4111	-	Snow Hill up platform, ?Leamington, lined green livery 84E shedplate	??/06/59	M21	G5
4111	-	Inside Tyseley straight shed with 3673	??/07/59	M22	150G
4111	K	Birmingham Snow Hill south end, light engine, centre roads	??/??/60	M117	AHS4
4111	A	Knowle & Dorridge stn, Tyseley breakdown train, Western diesel accident	15/08/63	M23	OBD
4112	B	Rowington Troughs, Birmingham-Leamington, 6 coaches, unlined black livery	30/04/55	MD24	SGW
4112	-	Warwick, Birmingham to Leamington stopper	16/02/57	MD25	BIG
4112	F	Oxford centre road for Hinksey Yard	??/??/60	I07	GWY2
4113	G	Wolvercot Junction, Oxford-Kingham, 1 coach	02/01/62	I08	MGW
4113	K	Honeybourne coaling stage, open wagons	??/07/62	J08	GWY2
4113	K	Passing Evesham WR signal box, up freight, opens and vans	??/7/62	J09	E222
4114	-	Kidderminster platform, taking water, Railcar passing from Woofferton + van	11/07/61	N07	GH
4114	K	Bridgnorth platform, taking water, depart southwards, opens 16T and vans	30/08/62	N08	BLM
4115	B	Over sidings, Gloucester 3 coach 4.08 pm from Hereford. Motor operated distant signal	10/06/61	J09	WGW
4115	-	Longhope platform, Hereford-Gloucester, ?3 coaches, 1 blood and custard	07/06/62	J10	WGS
4115	-	Inside Swindon Works, no cab or motion	28/07/63	C10	WES
4115	-	Inside Swindon ex-works, Grange class 6837 Forthampton Grange, Western diesel	18/08/63	C11	100
4116	B	Henley-in-Arden platform, Stratford-Birmingham local	??/04/57	MD26	G11
4116	B	Near Longhope stn vegetable plots, three coaches, 1 LMS Stanier, 2 BR Mk 1	16/6/62	J11	WGW
4117	B	Taunton platform, Yeovil-Minehead, M target, corridor coach, ?fireman coupling	04/10/47	E02	G87
4117	B	Exeter St Davids platform, Newton Abbot local, 6 coaches	31/08/56	F06	BIR
4117	B	Sea wall, Parsons Tunnel, ?Newton Abbot-Exeter, 4 coaches 1b&c	27/06/58	F07	GWV
4117	B	Exeter shed with 5153	12/07/58	F08	STW3
4117	A	Exeter St Davids platform 1, Taunton-Exeter, 6012 King Edward VI and 34061 72 Squadon	09/08/58	F09	SSW
4117	B	Parsons Tunnel signal box, Exeter-Newton Abbot, 6 coaches	14/07/59	F10	WS
4118	K	Shrewsbury platform 2, local mixed freight	28/08/52	N09 DET	NW1
4118	G	Hartlebury platform, Shrewsbury, ?3 coaches	??/??/53	N10	GWRB
4118	J	Ascending Hatton Bank, Tyseley, ?20 wagons	??/06/62	MD27	SCP

4119	A	Filton, Cardiff-Bristol, 7 coaches + SIPHON, some coaches clerestories, loco 1934 livery	??/?3?37	DS05	W32
4119	Pilot	Severn Tunnel to Pilning K freight, 42XX	09/05/58	DS06	GWSB
4120	G	Crewe Gresty Lane shed, outside, Hawkesworth & LMS tenders inside	??/?2/58	Q03	G65
4120	J	Leamington shed yard, 4171 near turntable road, 08 diesel shunter in yard, 2210 ditto	21/07/63	MD28	G59
4122	B	Tenby platform taking water, 3+ coaches, Whitland –Pembroke Dock	02/06/62	L01	GWB
4122	B	Whitland shed, coaling from 16T mineral wagon, 45XX and pannier tanks on scene	20/09/62	L02	G30
4123	B	West Kirby platform, Chester & Hooton	??/??/53	Q04	G27
4123	B	Longhope stn. FRUIT D van + 3 coaches	01/08/59	J12	WGW
4123	B	Pembroke Dock platform 2, Whitland, ?3 coaches	08/08/62	L03	ABL
4124	B	Parkgate stn, West Kirby-Hooton, 4 coaches, stone overbridge, crossover	02/08/56	Q05	SGW
4124	K	Honeybourne, 2 wagon pickup, passing 2222	??/06/64	J13	GWY2
4125	A	Banbury, York-Bournemouth, ?6 mixed coaches	27/09/59	I65	TRM
4125	-	Bordesley platform, up relief, coupled suburban coach, up main signals OFF	20/07/61	M29	WS
4125	K	Kings Sutton, Banbury, TOAD brake van only, loco lined green	??/06/62	I09	SCP
4125	G	Near Banbury gas works, loaded ironstone hoppers, ?Bilston West, 2L shedplate	21/10/63	I10	G88
4127	G	Stratford-upon-Avon, running round, ?Birmingham or Leamington, west box	??/??/57	MD30	G52
4128	B	Castle Barns, for Taunton, 2 coaches	??/04/61	E32	GW5
4128	B	Bishop's Lydeard platform, Taunton-Minehead, 4 coaches	11/07/62	E33	GBLG
4130	Pilot	Pontypool Road, banking mixed freight	??/??/50	K42	NW3B
4130	Pilot	Pilning, Severn Tunnel, full coal train ?25 wagons, train engine 2862, both STJ	25/05/63	DS07	STW3
4130	G	Gloucester Central up platform, ?Cardiff, ?4 coaches, Severn Tunnel Junction allocated	19/10/63	J14	G76
4131	-	Hallatrow platform for Bristol, coal train, photo taken from footplate, 57XX, 7772	??/??/57	D65	GSS
4132	B	Tenby platform, Whitland-Pembroke Dock, four coaches, loco taking water	08/08/62	L04	GWRB
4133	-	Leamington shed out of steam with 4151, 4178 in steam	29/03/64	MD31	BIR
4133	-	Snow Hill tunnel, Birmingham-Leamington Spa, only 1 coach visible	04/09/64	M32	G93
4134	B	Pontypool Road platform, Vale of Neath, loco BRITISH RAILWAYS and bufferbeam number	??/?8/48	K06	NW3B
4134	A	Swindon shed, lined green livery, bunker steps, 87G shedplate	26/02/57	C12	CL
4135	B	Near Longhope, four coaches for Hereford, engine 85C based	16/06/62	J15	WGW
4135	B	Longhope stn. 3 coaches + GUVan	16/06/62	J16	WGW
4135	B	Hereford Barrs Court stn, to Gloucester, 4 coaches, 1 full brake, 1 blood and custard	27/06/62	J17	NW3A
4136	B	Exeter St Davids platform, ??7coaches	??/?8/58	F11	SDN
4136	B	Teignmouth, Newton Abbot-Exeter, 4 coaches one full brake	10/10/58	F71	SPI
4138	B	Pontypool Road carriage sidings shunting empty bogie vans	31/07/54	K07	NW3B
4138	Pilot	Penpergwm goods loop, ?12 wagons, 7204,J,	??/??/55	K08	NW3B

		pilot Return As Ordered back to PPR			
4139	G	Buildwas low level + coaches, 4401 on Much Wenlock train on high level	??/??/51	N11	LLW
4141	B	Kingham branch platform, Kingham-Chipping Norton, 61XX in main platform with single brake third	??/??/61	I11	BCR
4141	B	Bourton-on-the-Water, Kingham-Cheltenham, station building	??/05/62	I12	GWY2
4141	-	Kingham, for Cheltenham ?2 coaches	15/10/62	I13	MGW
4141	B	Gloucester Central centre road, propelling 3 coaches to platform, ground signal off	??/?3/63	J18	NW3A
4142	B	Yatton platform, BTM to Weston-Super-Mare local, B set + 3 other coaches	??/??/49	D57	G88
4143	B	Stogumber stn, Taunton-Minehead, ?6 coaches	11/07/62	E03	GBLG
4143	A	Near Castle Cary, 2 coach westbound local	28/07/62	D04	GW4
4143	A	Crowcombe, 2.20 pm Minehead-Paddington, 8 coaches, Castle at Taunton	24/08/63	E04	WES
4144	B	Caerau, Bridgend-Cymmer Afan, 2 coaches, same train at Llangynwyd, next photo	01/06/62	K09	NOS
4144	-	Cardiff Canton shed, outside, lined green livery	03/06/62	K10	BIR
4144	-	Swindon ex-works outside with Standard Class 5, unidentified	??/05/64	C13	WSF
4145	Pilot	Dainton Bank, Exeter, Grange class 4-6-0, A	??/?8/57	F12	SPI
4145	Pilot	Dainton Bank, Liverpool-Plymouth, 6814 Enbourne Grange, A	28/08/57	F13	BRF
4145	Pilot A	Newport platform, D7031 failed Hymek with 5243, Paddington-Pembroke Dock, 75 m late	21/07/62	K45	0962
4146	B	Roundhouse turntable Tyseley shed, 2857 (SVR) in background, manually pushed	??/??/52	M33	GDG
4147	G	Bridgnorth platform/signalbox, Shrewsbury, LMS Ivatt 2-6-2T 41202 opposite platform	??/09/63	N12	SAR
4147	K	Cressage up platform by signalbox, Shrewsbury, ?10 wagons, opens, vans	??/10/63	N13	SAR
4148	B	Aynho troughs, 3 coaches, chalked front number	??/??/60	I14	GWM3
4148	G	Kennington Junction, 2.51 pm to Princes Risborough	26/08/61	I15	RC9
4148	-	Trusham platform, freight coupled to BR SHOCVAN, PRESFLO, opens and hoppers	24/03/62	F14	TVL
4149	-	Oxford shed ash road, 6367 on coaling ramp	08/09/61	I16	MGW
4149	B	Oxford platform, Banbury, 7030 Cranbrook Castle on adjacent road	31/05/62	I17	MGW
4149	G	Kennington Junction, Oxford-Princes Risborough	??/06/62	I18	MGW
4150	G	Bovey platform, 10.45 am Moretonhampstead-Newton Abbot, B set	19/02/59	F15	WS
4151	-	Leamington shed out of steam with 4133, 4178 in steam	29/03/64	MD34	BIR
4151	B	Running into Bearley station, 1 Gresley, 1 BR Mk 1 brake, both corridor	??/06/64	MD35	WSF
4152	Pilot	Severn Tunnel-E, coal train 72XX, K, private owner wagons	??/??/61	DS08	150G
4152	B	Holme Lacy platform, 13.26 from Hereford	14/08/64	J19	WGW
4153	B	Shrewsbury platform 9, Kidderminster, 3 coaches +TPO van, 85D shedplate	28/08/52	N14 DET	NW1
4153	G	Canal Bridge Worcester, Worcester-Ledbury, between Shrub Hill and Foregate stn	??/??/57	J20	WML

4153	Pilot	Bewdley –Cleobury Mortimer, Porthcawl excursion from Kidderminster, 7307	10/08/58	N15	BLB
4153	-	Outside Tyseley roundhouse	??/06/59	M36	GWE
4154	B	Honeybourne platform, Stratford-upon-Avon, BR suburban coach	??/??/57	J21	G55
4155	B	Bentley Heath, Lapworth-Snow Hill, 6 coaches, P Way gang in attendance	??/?6/59	M37	G99
4155	B	Ross-on-Wye platform, Hereford-Gloucester, ?4 coaches, 1 Hawkesworth	??/??/63	J22	G2
4155	H	Hatton Bank, for Birmingham, load of bricks ?30 wagons, opens	27/03/65	MD38	WES
4156	H	Severn Tunnel Junction platform, coach + 6 car carrier flats for car carrier service	06/04/64	K11	GWSB
4157	B	Quaker's Yard (High Level), Pontypool Road-Neath, taking water, 1+Hawkesworth coach	12/06/64	K12	STW3
4157	K	Gloucester Central platform from Hereford, 3 mixed coaches	27/06/64	J23	WGW
4157	B	Near Holme Lacy, 12.15 pm from Gloucester	17/10/64	J24	WGW
4158	-	Inside Wellington shed	??/05/59	N16	GWE
4159	J	Severn Tunnel East, car flats, car carrier	??/06/63	DS09	GWSB
4160	-	Kingham platform 3, running round for Cheltenham	??/??/64	I19	GWJ
4161	-	Outside Tyseley roundhouse	??/06/59	M39	GWE
4161	B	Leaving Gloucester Central for Ross-on-Wye and Hereford	??/10/64	J25	WGW
4161	G	Longhope stn 3 coaches.	30/07/64	J26	WGW
4161	B	Ross-on-Wye platform, 2249 passes with down passenger train.	25/05/63	J27	WGW
4161	B	Ross-on-Wye platform, Gloucester-Hereford, 3 coaches	04/04/64	J28	GBLG
4161	B	Mitcheldean Road platform, Gloucester-Hereford, 3 coaches	04/04/64	J29	GWRB
4161	G	Hereford Barrs Court stn, to Gloucester, 3 corridor coaches, 1 Hawkesworth brake	16/05/64	J30	NW3A
4161	B	Weston under Penyard Halt platform, Gloucester-Hereford, 3 coaches	??/??/64	J31	CS1
4163	-	St Mary's Crossing Halt, banking 3866 mostly mineral wagon freight	??/??/61	C14	SPI
4163	-	Kingham crossover from bay to Cheltenham	??/05/62	I20	GWY2
4165	D	WSH, centre road empty stock for express, loco number on bunker back	03/06/52	J72	G50
4166	-	Tyseley shed yard, black lined red/cream/grey livery, no BR emblem	19/12/48	M40	G87
4166	D	Paignton up platform, empty stock ?Goodrington CS, ?6 blood and custard	14/07/53	F16	G39
4166	-	Totnes milk siding, coupled to 6 wheel milk tanker	19/08/53	F17	GWS
4167	A	Exeter St. David's, Paddington via Tiverton	??/10/60	F18	RCS
4168	B	Malvern Link platform, Worcester-Hereford, ?4 coaches	05/08/58	J32	GW6
4170	-	Hatton, 10 am Leamington-Birmingham	06/11/56	MD41	GWJ
4170	-	Wellington (Salop) platform, 7.05 pm Wellington-Much Wenlock last day	21/07/62	N17	GWJ
4171	B	Longhope cattle pens, Hereford service, 3 coaches	02/10/64	J33	WGW
4172	D	Bentley Heath Crossing, 6 coaches empty stock from Snow Hill	10/06/59	M42	GW5
4173	B	Moor Street platform, Henley-in-Arden, ?4 coaches, 41XX other platform Leamington	??/06/57	M43	TFL

4174	B	Exeter St Davids platform, for Newton Abbot, 6 coaches 1 blood and custard	??/??/57	F19	SPI
4174	Pilot	Stoneycombe quarry, Paignton-Plymouth, 1008 County of Cardigan	??/?8/58	F20	GWW
4174	B	Lustleigh platform, Heart of Devon Rambler	06/06/60	F21	COL3
4174	B	Lyng Halt, Taunton-Langport East	??/??/61	E05	GSS
4175	Tail	Outside Tyseley roundhouse	??/06/59	M44	GWE
4175	B	Great Malvern platform, Worcester-Hereford, ?3 coaches, parcel weighing machine pltfrm	29/08/59	J34	E212
4175	A	Up relief Birmingham North signal box, terminating local, ?6 coaches	??/?8/60	M45	G103
4175	B	Worcester Shrub Hill, from down middle road, placement departure, ?3+coaches	01/06/62	J35	WS
4176	B	Exeter St Davids west end, Exeter-Kingswear, 4 coaches b&c, loco lined black	26/03/50	F22	GDG
4176	B	Teignmouth sea wall, Exeter-Newton Abbot, 7 coaches	18/08/50	F23	GWS
4176	G	Hatton stn south end, falling back after banking freight, LMS brake van + CCT	??/07/60	MD46	G19
4176	K	Hatton Goods Yard, shunting empty mineral wagons +TOAD	??/??/60	MD47	G76
4178	B	Kingkerswell platform, Exeter-Paignton train, 3 coaches b&c	??/05/57	F24	COL3
4178	B	Near Teignmouth, Exeter-Kingswear train	??/08/57	F25	GW6
4178	G	Much Wenlock signal box, light engine, running round corridor coach	27/05/61	N18	G31
4179	B	Aller Junction, Torquay, b&c coach, 5024 Carew Castle, Kingswear-Wolverhampton	21/08/54	F26	SGW
5100	-	Tyseley shed yard, renumbered from 99, 3100 in 1929, sliding cab shutter, slope tanks	??/??/3?	M48	G86
5101	B	Snow Hill, 4.35 pm from Stourbridge Junction via Dudley, ?6 coaches	30/08/58	M49	LLW
5102	K	Snow Hill, clerestory coaches, 1927 livery, Tyseley allocated.	??/??/31	M50	WMI
5103	A	Near Birkenhead Woodside, B'head-Bournemouth, ?8 GWR/SR coaches	??/??/50	Q06	TRI
5103	B	Ruabon platform, Llangollen local, 5 coaches	09/08/56	P27	BIR
5103	B	Between Bromborough & Spital, Chester-Birkenhead, ?5 coaches	??/05/58	Q07	PWR
5104	G	Leamington Spa platform, ?Stratford-upon-Avon, B set	??/??/52	M51	G58
5104	J	Farrington Gurney Halt, Bristol-Frome	17/10/59	D05	GBLG
5105	-	Swindon works grey livery, curved drop end, cushion boiler support, 4 ton bunker	??/?9/29	C15	G86
5105	A	Gloucester LMS junction from Cheltenham, 10 coaches, Gloucester change for Castle	??/07/58	J36	GWY2
5106	K	Shunting at Doublebois platform	??/10/58	H132	CRPS
5108	-	Tyseley shed yard, 1934 livery, roundhouse to rear, Dean and Collett coaches in sidings	06/05/39	M52	G87
5109	-	Leamington shed coal stage, 1927 livery, large coal, shorter safety valve bonnet	??/??/34	MD53	G86
5109	K	Wellington shed yard	??/?1/52	N19	G88
5109	K	Outside Wellington Shed, nearest road to station	??/??/52	N20	HIS
5110	B	Shrewsbury, station pilot + coaches	02/06/52	N21 DET	RCS
5110	Pilot	Severn Tunnel Junction goods loop, eastbound coal train + BR 9F 2-10-0	??/04/60	K13	GW2
5111	-	Chester General, centre road of west bay	07/06/38	Q08	G87

		platforms, pilot in between turns			
5114	B	Kings Sutton junction, Banbury-Kingham, Autotrailer No 11 + MEX, white roof	??/??/30	I21	BCR
5115	-	Tyseley near lifting shop, 1927 livery, outside brake rigging, tall safety valve cover	??/??/32	M54	G86
5117	-	Balderton crossing and signal box, Chester-Wrexham, GWR concertina coach	09/04/49	Q09	100
5118	B	Leamington platform, Birmingham-Leamington, 70 foot Toplight 4 coach set	??/??/29	MD55	G57
5118	H	Near Patchway, Severn Tunnel empties	??/??/3?	DS10	GW2
5118	H	Down goods loop Patchway stn. Mostly OPENs few MINKs and SR van 40+	??/?3/35	DS11	W30
5122	-	Wolverhampton Stafford Road Works, no firebox cladding, no cab	??/??/35	M56	WMI
5125	-	Tyseley shed yard, 1927 livery, outside brake rigging, firebricks in cab, 20T LOCO coal	??/??/36	M57	G86
5126	-	Swindon shed	??/??/30	C16	RCT9
5126	A	?Tyseley shed yard, curved drop ends, outside brake rigging front & centre drivers	??/??/33	M58	G86
5129	-	Tyseley shed yard, brake rodding fitted outside the leading and centre drivers	19/12/48	M59	G87
5132	B	Exeter St Davids, Torquay, 4 mixed GWR coaches in livery	05/06/49	F27	BIR
5133	-	Worcester shed yard, Rainbow Hill, water crane, Churchward tender in shot	05/05/37	J37	G87
5134	-	Stratford-upon-Avon shed, outside in steam	04/08/36	MD60	G52
5134	-	Swindon shed, Stourbridge Junction allocated, no 18 pilot banker turn	??/??/48	C17	GP3
5134	-	Swindon shed yard	??/??/50	C18	RCT9
5135	-	Stourbridge shed yard, 1934 monogram to the rear of tank, piles of ash and clinker	26/02/39	N22	G87
5136	B	Bentley Heath, Leamington, 70 foot Birmingham Division suburban 4 coaches	23/06/38	M61	G87
5136	-	Wolverhampton Stafford Road Works, heavy intermediate repair	07/05/50	M62	G88
5137	Pilot	Hatton incline, banking 2652, ironstone hoppers, ex-Banbury, 5137 Chester allocated	25/04/41	MD63	G94
5137	-	Cheltenham Spa St James, Hawkesworth coach, SR U class 31791 adjacent platform	??/09/61	J38	G43
5138	B	Snow Hill stn, light engine, waiting to take over service, 40-50 class seen in 24 hrs	??/??/35	M64	G86
5139	B	Birmingham, Leamington, ?6 coaches 70 foot toplights	??/??/4?	M65	GW1
5142	-	Swindon ex-works, 1927 livery, 4588 in attendance	??/??/31	C19	ZEN
5142	B	Wellington (Salop) stn, 4 coach Birmingham B set, plus other vehicles	03/08/35	N23	G33
5144	-	Swindon, chalked, 'Stock shed for factory' BRITISH RAILWAYS in GWR style, cut up	??/01/52	C20	G88
5146	K	Chester GWR shed yard, Sir Felix Pole LOCO coal wagon and LNWR signals background	07/06/38	Q10	G87
5147	A	?Stourbridge Junction shed, 36XX 2-4-2T behind, straight drop end, coned buffers	??/??/32	N24	G86
5147	K	Snow Hill, local freight, ?30 wagons, opens & vans some sheeted	06/05/48	M66	G101
5148	A	Chester GWR shed outside, oiling round	26/08/37	Q11	G87
5148	F	Liskeard viaduct, mixed freight	??/07/58	H133	GW1
5149	-	Tyseley shed yard, straight drop end, large bunker, tall safety valve bonnet	??/??/31	M67	G86

5150	-	Crewe stn as built in 1930, 1927 livery	??/??/31	Q12	RCT9
5150	Tail	Totnes platform, light engine, regular assist engine up Dainton and Rattery inclines	20/09/45	F28	G87
5150	B	Goodrington Bank, Kingswear portion, Wolverhampton-West of England, ?4 coach	28/03/54	F29	BRF
5150	B	Leaving Dainton Tunnel, Exeter-Plymouth, mixed coaches	04/08/56	F30	CL
5152	B	Hatton Bank, Leamington-Birmingham, 4 coaches, passes 5185 banking mixed freight	28/02/53	MD68	SGW
5152	-	Chipping Norton, waits to pass 6111 on REC special	14/09/63	I22	BIR
5152	F	Oxford north, ironstone hoppers, Hinksey Yard	??/??/6?	I23	RC9
5153	A	Near Churston, ?6 coaches, Kingswear portion of 2.30 pm Paddington	30/03/62	F31	COL3
5154	-	Moretonhampstead running round coaches, Newton Abbot, ground signal for crossover	??/??/57	F32	LBR
5154	B	Kingham, Cheltenham Spa St James, ?2 corridor coaches	31/06/62	I24	G34
5155	-	Stourbridge Jct shed yard, Early BRITISH RAILWAYS lettering, STB and 84F shed plate	??/?7/49	N25	G87
5155	-	Stourbridge Junction platform, ?Snow Hill/Wolverhampton local passenger	10/10/49	N26	G87
5156	Pilot	Near Dainton tunnel, 13 coaches, Castle, A, No 4 Target Newton Abbot-Totnes	??/??/47	F33	G87
5156	K	Location unknown, Tyseley allocated, pickup goods	??/?2/56	M69	G87
5157	A	Minehead platform 1, ?5 coaches, wood MINK in goods yard siding	??/?7/55	E06	LB
5158	-	Weston-Super-Mare, shunting goods yard between passenger stations, CONFLAT, opens, LMS van, old tank engine in yard	25/05/37	E07	G87
5158	A	BTM, Weston-Super-Mare-Paddington, Handover to 5022 Wigmore Castle	??/??/3?	D59	W32
5161	K	Near Leamington, pickup goods, 8 wagons, opens + BR brake van	08/06/54	MD70	BIG
5162	-	Inside Tyseley loco repair works	??/??/34	M71	WMI
5162	D	Snow Hill stn, 3 parcels vans, 1 outside frame SIPHON G	??/??/36	M72	G86
5162	B	Claverdon stn, Leamington-Stratford-upon-Avon, 1 Dean 1 Collett coach	??/04/39	MD73	G38
5162	-	?Neyland, ?Milford Haven, ?bow ended B set coach	??/04/52	L05	G88
5163	G	Hatton bank, all stns Snow Hill to Leamington Spa, 4 coach B set.	??/?3?40	M74	WMI
5164	Tail	Totnes, Rattery bank, assisting 2843 on minerals, 22 full unassisted, 40 full assisted	15/07/58	F72	G88
5164	Tail	Pontypool Road stn taking water	20/08/62	K14	COL3
5165	D	Long Marston loop, waiting with empty stock for passage of Cornishman, Castle hauled	??/?7/62	J39	G68
5166	B	Snow Hill platform, 12.35 pm Stratford-upon-Avon coaching stock	08/09/56	M75	GW4
5166	B	Stratford-upon-Avon, for Birmingham	21/04/57	MD76	GW2
5167	B	1927 livery, Empty stock for Snow Hill to Leamington Spa (allocated) , A set coaches	07/09/34	M77	WWG
5167	G	Birmingham Snow Hill, shunting coaches into down bay platform, from North S Box	??/??/36	M78	GWW
5167	F	Kings Sutton, Banbury-Oxford, 60 wagons	23/06/61	I25	BIR
5168	A	Rock Ferry platform, Birkenhead-Chester,	??/??/47	Q13	G87

		corridor coach, joint LNWR/GWR lines			
5171	B	Ponthir platform, Blaenavon-Newport, 2 coaches, wooden post signal off	20/06/57	K15	NW3B
5172	B	Norton Fitzwarren, Paddington-Minehead, ?5 coaches, loco M for Mnhd target, 1934 livery	06/09/47	E37	BLS
5172	Pilot	?Whiteball incline, Taunton-Paddington, ?8 coaches, BR Standard Class 5 train engine	??/??/56	E08	G88
5173	B	Bourton-on-the-Water westbound platform, 2 coaches	??/??/61	I26	BCR
5173	B	Bourton-on-the-Water, Kingham platform, 2 coaches	26/05/61	I73	AHS2
5173	B	Bourton-on-the-Water loop passing 4101	??/05/62	I27	GWY2
5173	B	Cheltenham Leckhampton, 1.50 pm Cheltenham-Kingham, ?B set	23/06/62	J73	1262
5174	A	Bont Newydd, Barmouth to Ruabon, 11 coaches, piloted Dean Goods 2464	11/08/34	P28	CAM2
5174	J	Saltney yard, Chester, mixed freight ?30 wagons	15/06/57	Q14	SWC
5175	B	Leamington Spa platform, corridor coach, 1927 livery	??/??/35	MD79	G86
5175	-	Laira coal stage with BR Britannia 70021 Morning Star	23/05/56	G84	E224
5177	-	Tyseley shed yard, 1927 livery, Stourbridge allocated	??/??/35	M80	G86
5178	G	Dudley up GW platform, Snow Hill, 4 coach local set	12/04/47	N27	G23
5179	B	Chester bay platform, Birkenhead train	??/?8/51	Q15	CRO
5180	-	Rodbourne Lane, Swindon, new smokebox number and shedplates, Stourbridge alloc.	??/?1/49	C21	G87
5181	G	Leamington platform, Banbury, 2 clerestories+4 coach 57' suburban set	??/??/36	MD81	G57
5182	K	Brimscombe shed, outside next to coal wagon, adjacent water crane	??/??/56	C22	HIS
5182	G	Swindon ex-works lined passenger livery, later BR emblem	??/??/57	C23	150
5182	B	Brimscombe platform deputising for 0-4-2T 14XX class, Chalford, ?2 auto-trailers	07/08/61	C24	WSF
5183	G	Lustleigh platform, Mortonhampstead-Newton Abbot, B set	20/04/57	F34	ABL
5183	G	Mortonhampstead platform, Newton Abbot, B set	20/04/57	F35	ABL
5183	A	Newton Abbot platform, Kingswear, 8 blood and custard coaches	??/07/57	F36	SCP
5183	-	Bovey platform, exchanging electric train token with signalman	19/02/59	F37	WS
5183	B	Droitwich Spa platform, for Worcester, ? outside framed SIPHON G plus B set	17/06/61	J71	AHS4
5184	B	Leamington Spa-Snow Hill-Wolverhampton Low Level, 1927 livery, 6 mixed coaches	??/??/31	MD82	WMI
5185	-	Chester shed yard, cab detail, toolboxes, fire irons	??/??/33	Q16	G79
5185	-	Chester shed yard, 3 photos of detail of cab side, bunker and LH cylinder and steam-pipe	??/??/33	Q17	G86
5185	B	Down Hatton Bank, Birmingham-Leamington, non-corridor coach	07/03/54	MD83	SGW
5185	G	Up Hatton Bank, ?Birmingham-Leamington, B set + brake third non corridor	14/08/54	MD84	GDG
5185	B	Hatton platform, Moor St commuter train, 3 coaches	??/05/57	MD85	TFL

5185	B	Stratford-upon-Avon platform, ?1.15 pm Leamington-Honeybourne, loco Leamington	??/??/57	MD86	G52
5185	-	Minehead shed, outside	23/08/59	E09	GWE
5186	B	Chester bay platform, Birkenhead, GWR liveried coach behind	??/??/5?	Q18	G88
5187	G	Leamington Spa stn. All stns. Snow Hill & Wolverhampton LL, 4 coach B set	??/??/38	MD87	WMI
5189	Tail	Outside Wellington (Salop) shed with Dean Barnum O/F 2-4-0 3222	??/??/3?	N28	SAR
5190	-	Tyseley works outside, BRITISH RAILWAYS, lined, TYS twice on cylinders	22/05/49	M88	STW3 G87
5190	B	Appleford Crossing, Oxford-Didcot, 3 coaches + van	??/??/59	C25	MGW
5192	A	Snow Hill, excursion, 6 coaches Dreadnought and other GWR	03/08/35	M89	GW2
5193	G	Newquay platform, for Par, ?6 coaches chocolate and cream	15/06/58	H137	GBLG
5193	B	Luxulyan platform, Par-Newquay, 3 coaches	20/06/58	H133	ABL
5195	-	Wellington (Salop) shed yard, 20 ton Sir Felix Pole coal wagon, Crewe Gresty Lane alloc.	27/08/37	N29	G87
5195	-	Crewe station, uncoupling from Wellington ?B set coach	??/??/37	Q19	ZEN
5195	K	Totnes stn, taking water between banking duties on Dainton and Rattery banks	??/?7/57	F73	SPI
5196	B	Snow Hill, 3.55pm to Stourbridge Junction, 4 GWR liveried coaches, loco 1945 livery	05/08/47	M90	BIR
5196	Pilot Tail	Dainton tunnel, banking open wagon freight, 2875 train engine	28/08/57	F38	EGW
5197	-	Stourbridge Junction shed yard, 1927 livery, white roofed coaches in the rear	21/09/35	N30	G86
5197	G	Hatton, Birmingham-Leamington, 8 coaches	??/??/38	MD91	G19
5198	B	Par 1 in 57 down, ?Truro, 5 coaches, 1 b&c, tubular post signals OFF	??/06/60	H134	WS
5198	G	Par for St. Blazey shed, running light	??/06/60	H135	SCP
5198	Pilot	Quintrell Downs, 11.15 am Newquay-Wolves, 12 coach, 1002 County of Berks, bunker 1st	09/07/60	H136	TDH TGM
6100	A	Paddington, by goods depot, clerestory and Collett coaches	13/06/31	A06	GW2
6100	G	Cholsey & Moulsford up slow platform, mixed freight ?30 wagons, 81D shedplate	07/04/53	C26	SGW
6101	J	Sonning Cutting, Slough to Reading West Junction, ?30 mixed wagons	??/04/55	B01	BIR
6101	-	Reading shed outside later building addition	04/09/60	C27	GWS
6102	A	Southcote Junction, Reading-Newbury, 6 coaches, dreadnought, clerestory, Collett	??/?6/31	C28	GW1
6102	A	Southcote Junction Reading, Paddington-Hungerford, coaches as per previous entry	??/??/39	C29	BIR
6102	G	Aynho flyover, Ardley&Bicester, 1 autocoach	18/12/54	I28	SGW
6103	B	High Wycombe, from Banbury only 1 coach visible	06/06/53	B02	BIR
6103	A	Old Oak Common, Paddington-Reading, Mixed blood and custard coaches	12/04/58	A07	EGW
6104	B	Reading West local, 3 coaches	29/06/57	C30	BIR
6105	A	Goring-on-Thames, Paddington-Oxford, Dean + ?6 Collett coaches	??/06/32	C31	W32
6106	-	Wheatley platform, Oxford-Princes Risborough, 6111 also, with train, snowy	05/01/63	I29	MGW
6106	-	Near Basingstoke, freight, passing 7914 Lleweni Hall on short van train	??/??/63	C32	SPI

6106	G	Brimscombe shed, Sapperton banker	26/09/64	C33	GW2
6106	-	Reading shed after closure	03/01/65	C34	RCR
6107	D	Weston super Mare, Locking Road stn, empty stock, 8 coaches	26/05/58	E10	GWV
6108	K	Paddington 10 platform line, Arrival signal box, light engine	20/08/38	A08	G5
6108	A	Paddington platform, Bourne End, 4 coach A set+1 coach	??/08/39	A09	G76
6108	C	Paddington platform?8/9, ?among last steam worked suburban service Reading/Slough	??/04/63	A36	E225
6110	-	Swindon ex-works as built works photo	??/08/31	C35	RCT9
6110	B	Oxford No 1 up platform, Paddington, 6 coaches +van, loco Old Oak Common	??/??/59	I30	G64
6111	-	Gerrards Cross, ?High Wycombe-Paddington, loco 1927 livery, panelled coach	??/??/35	B03	G5
6111	B	Thame, Oxford-Princes Risborough, 3 coaches, snowy	05/01/63	I31	MGW
6111	A	Hook Norton stn, REC railtour	14/09/63	I32	GWRB
6111	D	Oxford, parcels from Paddington	08/08/64	I33	MGW
6111	K	Oxford stn approach, backing down onto vehicles in platform	08/08/64	I34	G64
6111	K	Culham platform, mixed freight 20+ wagons	02/07/65	C36	MGW
6112	K	Kensal Green, Paddington-West Drayton, 6 uniform Collett coaches	07/08/32	A10	100
6112	-	Oxford centre road, cement hoppers for Hinksey Yard	??/??/60	I70	GWY2
6112	-	Outside Oxford shed, 5914 Ripon Hall inside	??/04/62	I35	MGW
6112	Tail	Oxford stn, backing onto coach(es) in the platform	??/06/64	I71	WSF
6113	B	Scrubs Lane, Old Oak Common, down line, 6 coaches, clerestories background, boy	??/??/33	A11	CL
6113	K	Slough up platform, ?Windsor service, 2 coaches, loco 1927 livery	??/??/34	B04	ZEN
6113	B	West end Sonning Cutting, Reading-Paddington, 5 coaches	13/04/57	B05	EGW
6113	B	Dunster platform, Minehead, 4 coaches	??/??/60	E11	GSS
6114	Pilot	Severn Tunnel eastbound, loaded coal train, 2894, K, ?35 wagons	09/05/58	DS12	GW1
6114	B	Clarbeston Road platform taking water, 2.05 pm Fishguard Harbour	20/06/62	L06	100
6115	A	Near Iver, Slough-Paddington, up fast main	19/05/57	B06	GW4
6115	-	Kennington Junction, Princes Risborough W87 autocoach only	??/??/57	I36	MGW
6115	A	Pilning HL platform, Bristol Zoo Special	??/07/63	DS13	GWSB
6116	B	Hayes up line, 5 mixed coaches, clerestories, Collett and others	10/10/37	B07	G5
6116	K	Tyseley roundhouse being cleaned	23/05/59	M92	GWE
6116	B	Whitland platform 3, Pembroke, 2 coaches	??/?6/61	L07	GWJ
6116	-	Receiving coal at Radyr shed	??/??/64	K16	100
6117	B	Near Reading, Reading-Newbury, 3 GWR corridor coaches	10/04/55	C37	G55
6117	B	Running round its train from suburban platform at Paddington, lined green livery	06/03/58	A12	TRI
6118	G	Slough, Aldin siding, light engine, GWR lettering	??/??/47	B08	G41
6118	F	Goring troughs up relief, ?Moreton Yard-Reading SR, ?25 wagons, opens few vans	??/??/56	C38	G97
6118	-	Neyland shed outside, 5508, both Neyland allocated	??/06/63	L08	STW3

6119	A	Paddington platform, Windsor, 1 third class+4 coach, Wyman's kiosk	??/05/39	A13	G76
6119	B	Parsons Tunnel signal box, ?Newton Abbot-Exeter, ?4 coaches, 2 b&c	14/07/59	F39	WS
6120	F	Wolvercot siding signal box down goods running loop, mostly vans some opens	??/??/55	I37	HGW
6120	B	Oxford platform, Thames Valley stopper, 6 coaches	??/??/59	I38	MGW
6123	A	Acton West signal box, Paddington-?Reading, 5 coaches, 9704 on trip freight	30/08/56	B09	G4
6123	A	Bletchington, Oxford-Banbury, ?5 coaches	06/11/63	I39	MGW
6124	A	Westbourne Park stn, Paddington-Henley-on-Thames, ?6 coaches	14/07/37	A14	ZEN
6124	-	Didcot shed yard with 6153	19/03/61	C39	MGW
6126	B	Denchworth, Didcot-Swindon, 3 Collett +clerestory coach+?van, running in Swindon	20/08/38	C40	G5
6126	B	Gerrards Cross, Paddington-High Wycombe, ?7 coaches, BRITISH RAILWAYS W suffix	??/??/50	B10	GDG
6126	K	Wantage Road platform, steam crane, TOAD, OPENs, other brake van	??/??/60	C41	HGW
6126	B	Bourton-on-the-Water platform, Kingham-Cheltenham, ?2 coaches	??/??/61	I40	G26
6126	K	Aristotle Lane Oxford, LNWR route, Bicester Ordnance depot to Hinksey Yard	01/03/65	I41	MGW
6126	A	Oxford Road Junction, Yarnton-LCGB special, ?10 coaches	15/08/65	I42	HGW
6128	B	Near Longhope stn. Hereford-Gloucester, 3 coaches + 2 vans, 85B allocated	16/08/64	J40	WGW
6129	-	Sonning Cutting, Reading-Paddington passes 6115, Paddington-Reading 5 coaches	11/06/57	B11	EGW
6129	-	Reading shed yard with classmate 6138 behind, ?Mogul buffered up	04/09/60	C42	GWS
6129	-	Oxford shed yard, OURS headboard, Princes Risborough dining special	24/02/62	I43	MGW
6129	B	Oxford platform, 4.45 pm Princes Risborough	06/05/62	I44	MGW
6130	A	Ealing down fast, Paddington-High Wycombe, 4 coaches, GWR light signals	01/05/37	B12	G5
6130	B	Near Beaconsfield, Paddington-Aylesbury, Aylesbury allocated	20/02/38	B13	G5
6130	B	Shrivenham stn, Reading-Swindon, ?6 coaches, rail built loading gauge	06/03/54	C43	SGW
6131	B	East end Slough stn, Paddington-Reading, 4 coaches 1 white roof, 1934 livery	??/??/38	B14	G5
6131	A	West Ealing, Paddington, DH 6161, ?7 coaches, 1, 70 foot concertina	15/03/52	B15	TRI
6131	B	Redbridge, Oxford – Didcot, 3 coaches + van	??/??/5?	I45	MGW
6132	B	Uxbridge Vine Street, Paddington, ?4 coaches, 2 blood and custard	??/02/52	B16	GWRB
6132	C	West Ealing milk depot, Kensington tankers plus coach, road tanker being filled	??/??/60	B49	1062
6132	G	Southall shed, outside unlined green livery, 92224 on adjacent road	14/10/62	B17	BIR
6133	-	Slough shed yard, 1927 livery	04/10/36	B18	G5
6133	B	Loudwater platform, High Wycombe-Maidenhead, 5 coaches, 9015 passing freight	10/08/50	B19	G27
6133	B	WSH, Leamington via Honeybourne, ?3 coaches, loco Southall allocated	27/12/60	J41	G50
6133	C	Paddington approach, empty stock, 6003	12/08/61	A15	G78

		King George IV, Red Dragon, chocolate& crm			
6133	B	Southall shed, with 8456, 6967 Willesley Hall, + Hall and Manor engines	15/05/63	B20	STW3
6135	-	Old Oak Common roundhouse with 4703, 6163, 3618, 1500 and 9405, all OOC allocated	24/11/63	A16	G75
6136	G	Slough shed yard, 1927 livery	04/10/36	B21	G5
6136	B	Slough platform, Paddington, loco 1945 GWR lettered livery, coach ?earlier	14/05/49	B22	G41
6136	K	Hinksey Yard Oxford, up mixed freight, loco Slough allocated	??/03/60	I46	BIR
6136	G	Tilehurst platform, for Didcot light engine, semaphore signalling extant, changeover	??/?3/64	C44	SPI
6137	-	Chipping Norton platform, Chipping Norton-Kingham, ?B set, by signal box, water tower	??/??/47	I47	BCR
6137	B	Yatton, BTM, 8 GWR coaches, 1 LMS	??/06/58	D60	E160
6137	B	Bourton-on-the-Water platform, Kingham, crossing train, both ?B set	??/06/60	I48	G40
6137		Charlton Kings, Cheltenham-Andoversford, ?2 coaches, single passenger on platform	??/??/60	J42	BCR
6137	B	Cheltenham Spa St James platform, ?2 coaches, CORDONs and b&c coach	??/??/60	J43	BCR
6137	B	Longhope stn, 3 coaches + ?vans, tablet apparatus	??/08/62	J44	WGW
6137	B	Ross-on-Wye platform, taking water, signal off	??/?8/62	J45	WGW
6138	G	Radley, Didcot-Oxford, 3 blood and custard coaches, 1 Hawksworth	10/06/57	I49	MGW
6138	B	Basingstoke, Reading local, 3 blood and custard BR Mk 1 coaches	??/03/60	C76	SCP
6138	K	Southall shed yard, water tower and softening plant	04/09/60	B23	GWS
6140	B	Castle Bar Park Halt, 1.33pm Paddington-Reading, 6 coaches, another 61XX	16/02/58	B24	GBLG
6141	B	Cookham, Aylesbury-Paddington, 6 coach local C set+2 main line coaches at rear	??/??/54	B25	G55
6141	G	Southall shed yard, with BR 9F 2-10-0 and 94XX pannier tank	04/09/60	B26	GWS
6142	G	Ruislip Gardens, engineers train, LNER Thompson L1 2-6-4T BRITISH RAILWAYS	??/??/49	B27	TFL
6142	D	Scrubs Lane, down main line empty stock, ?9 coaches	07/04/58	A17	TRI
6143	C	Approaching Oxford platform 1, empty stock, 4 coaches, 1435, G taking water near shed	??/??/59	I50	G64
6143	-	Slough shed outside, with 9415	26/03/61	B28	STW3
6143	J	Iver up slow, ?Acton Yard, 6+opens and CONFLAT	03/03/62	B29	G85
6144	A	Arriving Royal Oak platform, passing 4082	25/02/56	A18	GWM3
6145	A	Near West Drayton, Paddington-Slough, 8 coach suburban set	02/05/47	B30	G5
6145	B	Reading bay pltfrm, Newbury GWR coaches	12/05/51	C45	RCR
6145	D	Becket Street footbridge Oxford, parcels to Paddington	28/08/63	I51	MGW
6146	B	?Slough, Paddington-Slough, BR suburban+5 coaches	??/??/58	B31	G55
6147	B	Slough shed yard, 1927 livery	04/10/36	B32	G5
6147	B	Slough bay platform, Windsor Central, 3 coaches, 1st SLIP	??/03/38	B33	GW1
6147	B	Hanwell & Elthorne stn, 11.14 am Windsor to Paddingon crossing 11.35 am Pddngton-Win	08/04/55	B34	GW4

6147	K	Moreton-in-Marsh, shunting, goods lockup	27/03/64	I52	GWY2
6147	-	Swindon ex-works yard, ex-LMS Ivatt 2-6-0 buffered up	26/04/64	C46	GWS
6148	-	Langley platform, Paddington suburban, toplight coach	??/??/38	B35	G32
6148	G	Outside Paddington, light engine, lined green, Southall allocated	20/06/59	A19	G13
6148	A	Congresbury platform, Cheddar Valley + 6148, Home Counties Railway Society	09/10/63	D06	GSS
6149	B	Thame stn, for Princes Risborough, 3 coaches	20/03/62	I53	GBLG
6150	K	Oxford North Junction, 6 bogie bolsters, concrete bridge components	??/10/63	I54	GWM3
6151	B	Moreton Cutting, ?Oxford-Paddington, 8 corridor coaches, SR N15X 32330 on freight	14/09/53	C77	G90
6152	B	Paddington platform 14, ?7.45 pm Slough, 3rd rail electrified tracks, AWS shoe clipped up	24/06/47	A20	G78
6153	B	West of Princes Risborough, Thame branch, Watlington alongside, 7 coaches	??/??/52	I55	G20
6153	G	Swindon shed yard, 57XX buffered up, BR 9F 2-10-0 behind	04/09/60	C47	GWS
6153	-	Didcot shed yard with 6124	19/03/61	C48	MGW
6154	A	Paddington platform, concertina coach strengthener, 7 coaches	06/09/49	A21	G78
6154	?J	Oxford shed yard with 7249, 7900 St. Peter's Hall – see also entry for 6156	24/03/63	I56	MGW
6154	K	Kennington box, Morris Cowley-Hinksey Yard, Mini, 1100, MG Midget cars loaded	29/06/63	I57	G89
6155	B	Scrubs Lane, Paddington-?Oxford, 7 coaches, 1 of which clerestory	02/09/34	A22	ZEN
6155	A	Taunton, 11.15 am Minehead-Paddington, 9 coaches, 7006 Lydford Castle +5 Taunton	30/06/62	E34	TDH
6155	-	Swindon ex-works	23/08/63	C49	PVSL
6155	F	Sapperton Tunnel, Empty ballast hoppers + SHARK	??/??/63	C50	SPI
6155	E	Norton Junction, Evesham-Worcester freight, 5 loaded 16T, 2 vans, 1-16T, TOAD	19/09/64	J46	CL
6156	-	Southall shed, with 1436, both Southall	10/04/57	B36	STW3
6156	B	Castle Bar Park Halt platform, Paddington-Reading, 6 coaches, concrete footbridge	16/02/58	B37	ABL
6156	K	Finstock, 8 wagon pickup, LMS brake van	22/09/62	I58	MGW
6156	-	Oxford shed yard with 92220 Evening Star and 6154	24/03/63	I59	MGW
6157	A	Paddington platform + train, 1934 livery	02/07/38	A23	GWM3
6157	G	Windsor & Eton Central, Paddington, 6 coaches	??/??/57	B38	SPI
6157	-	Taunton stn. carriage shunting	06/04/62	E35	GSS
6158	B	Twyford platform, Paddington-Reading,?6 coaches	12/10/58	B39	GBLG
6158	B	Oxford platform, 6 coaches, OOC allocated	??/??/60	I60	GWM3
6158	B	Chepstow signal box and goods shed, 2 coaches	??/?8/62	K17	WGW
6159	K	Gloucester Central platform, Hereford stopper, 4 coaches	??/07/59	J47	WGW
6160	B	Windsor platform, Paddington, Main line and city coaching stock	??/??/39	B40	G14
6160	B	Slough stn centre siding, shunting ?Paddington, GWR style BRITISH RAILWAYS	14/05/49	B41	G41
6161	J	West Junction Reading, 5 wagon pickup	??/03/60	C51	GW6

6161	-	Paddington platform, empty coaching stock for ?Old Oak Common	16/05/64	A24	G82
6162	-	Outside Didcot Repair shop	??/??/47	C52	FIR
6162	G	Outside Reading shed, BR 9F 2-10-0 92245, Castle and 8750 class pannier tank	??/??/63	C53	HIS
6163	B	?Location, Basingstoke-Reading, 3 LSWR coaches, 1 GWR, standard set for duty	??/??/36	C54	G55
6163	-	Paddington platform 8, empty stock	12/08/61	A25	G78
6164	Tail	Slough shed	??/06/59	B42	GWE
6164	G	Old Oak Common shed, outside with 8750 class pannier tank, coal stage in shot	01/10/61	A26	G92
6165	C	Old Oak Common, empty coach stock, loco plain green livery	19/10/63	A27	WES
6165	C	Paddington, empty coaching stock, all maroon	08/11/63	A28	G89
6165	-	Inside Didcot shed	21/04/65	C55	GWE
6166	B	Near Seer Green Halt, Paddington-Aylesbury, 4 coaches + clerestory, Aylesbury allocated	22/05/38	B43	G5
6166	A	Leaving Paddington pm outer suburban, ?8 coaches, 6953 Kimberley Hall light engine	21/07/49	A29	G68
6166	A	West of Newton Abbot, Kingswear portion of Paddington express, 4 chocolate & cream c	??/?7/59	F40	GWW
6167	-	Leaving Paddington, Slough local, ?coaches	24/04/57	A30	CL
6167	-	Paddington empty stock move	19/08/57	A31	GW4
6167	G	Maidenhead, Wycombe platform/bay, 3 coaches	08/08/59	B44	G36
6167	J	West Wycombe, mineral train, 16T and 20T wagons ?15+TOAD	26/09/64	B45	TFL
6168	B	Southall platform, Paddington, C set coaches	??/05/56	B46	G20
6169	B	Westbourne Park, Paddington down stopper, Loco GWR livery, smokebox numberplate	??/11/49	A32	TRI CL
8100	-	Leamington shed with 2838, 5700	12/02/39	MD93	WMI
8100	B	Solihull platform, Birmingham, 4 coaches	21/04/47	M94	TFL
8100	-	Leamington shed inside with GWR railcar W22	17/06/51	MD95	BIR
8100	B	Hatton platform, 3 coach evening local	??/05/56	MD96	GW4
8103	-	Swindon ex-works, 1934 livery	01/11/38	C56	GWY2
8104	-	Worcester shed, outside LH motion dis-assembled	??/05/64	J48	WSF
8105	B	Stratford-upon-Avon, ?Moor Street or Evesham, ?3 coaches, loco Evesham alloc.	26/07/52	MD97	G52
8106	B	Near Warwick, 3 coach Leamington Spa - Worcester	02/03/57	MD98	GW4
8106	B	Bourton-on-the-Water platform, Kingham, 2 coaches	17/07/62	I61	G40
8106	K	Fladbury, Worcester, ?14 wagons	??/03/63	J49	SCP
8108	B	Henley-in-Arden platform, Moor Street-Stratford, 4 Collett non corridor coaches	??/??/47	MD99	G11
8109	B	Passing Warwick Cape goods yard, Leamington-Birmingham, 3 coaches	??/05/55	MD100	G70
8109	-	Leamington shed with WD 2-8-0 90483	26/07/58	MD101	STW3
8109	A	Worcester SH, Kidderminster portion of Cathedrals Express, 7027 opposite platform	28/07/60	J50	TDH
8109	-	Outside Swindon ex-works, plain black livery	24/03/63	C57	SDN
8109	B	East of Birmingham, Lapworth-Birmingham, 6 Mk 1 coaches	27/06/63	M102	WES
8109	B	Acocks Green, Snow Hill-Leamington Spa, ?5 coaches	??/07/64	M103	WSF
8109	-	Henley in Arden platform by footbridge,	15/09/64	MD104	GWS

		coupled to SR Utility Van, S691S			
4400	-	Siding outside Much Wenlock shed. ?Arrived mixed train from Ketley, shunting goods	10/09/49	N31	G80
4401	K	Wellington stn, ?station pilot, LMS (ex-LNWR) Webb Cauliflower 8583 from Stafford	03/08/35	N32	G33
4401	G	Rushbury platform, 3.10 pm Wellington-Craven Arms, 2 coaches	05/04/51	N33	GW1
4401	G	Craven Arms & Stokesay down platform, Much Wenlock, 2 corridor coaches	21/04/51	N34	NW2
4401	-	Buildwas Junction, Craven Arms to Much Wenlock, GWR corridor coach visible	24/07/51	N35	BLB
4401	G	Exeter shed yard, cycling lion emblem	??/??/52	F41	G81
4401	-	Princetown platform coupled to coach	??/08/53	G01	BLT
4402	B	As built and numbered 3102 on tank side, small bunker, no top feed	??/??/15	C58	G81
4402	B	Princetown platform, Westinghouse pump and reservoir, flange oilers	??/09/31	G02	G80
4402	B	Burrator Halt, 6.55pm Yelverton-Princetown, single clerestory brake only	20/06/34	G03	GWV
4402	-	Plymouth Laira shed yard, coaling stage behind with Mogul 2-6-0	??/08/35	G04	GWS
4403	G	St Erth stn coupled large SIPHON, allocated St Ives shed and Helston worked	09/08/23	H01D	G80
4403	-	Princetown shunting goods yard coupled to TOAD in 1922 livery	15/06/26	G05	BLT
4403	-	Penzance shed yard, worked Hayle, Helston and St Ives	??/??/30	H02D	G80
4403	-	Tondu shunting, used on Porthcawl branch	??/??/32	K18	G80
4403	G	Wellington bay platform, Much Wenlock, ?4 coaches, coupling on gedge hook	06/05/35	N36	SAR
4403	-	Much Wenlock shed with 4401 inside Tail, autocoach on loop line	28/06/36	N37	WMI
4403	G	Burrator Platform Halt, 2 coaches	04/07/52	G06	GWRB
4403	G	Princetown, shunting empty stock, 1 coach	04/07/52	G07	GWRB
4404	-	As built and numbered 3104 on tank side decorative oil patterns, also bunker shot	??/??/?5	C59	G81
4404	-	Tondu shed yard, BRITISH RAILWAYS GWR Egyptian serif style, power class cab-side	29/08/48	K19	G80
4405	-	Laira shed yard, Bulldog 4-4-0 and Halt in background	??/??/33	G08	G80
4405	K	Looe platform, Liskeard, 1929 B set, marked on end LOOE BRANCH No 1	25/05/35	H03	GWW
4405	K	Dainton Tunnel, Ashburton-Newton Abbot goods, ?12 wagons, open, CONFLAT, TOAD	??/??/47	F78	G85
4405	-	Ashburton loop, 3 CONFLAT, 2 OPEN+TOAD	??/??/49	F42	BLT
4405	B	Near Torquay stn, Paignton-Paddington, 7 mixed coaches	10/04/52	F76	100
4405	-	Ashburton loop + bogie bolster + steel	??/?6/52	F43	BLT
4405	B	Totnes stn centre road, open wagons	19/08/53	F44	GWS
4406	G	Ketley stn, B set coaches	??/09/47	N38	WMI
4406	G	Wellington shed coal stage, WLN above cylinder, neglected	13/11/48	N39	G80
4406	G	Wellington (Salop) bay platform, Much Wenlock, 2 GWR coaches + van	??/??/51	N40	GWRB
4406	B	Pyle platform, 12.40 pm Porthcawl-Tondu, 3 coaches	13/09/52	K20	GWS
4407	B	Yelverton, Princetown, 2 coaches	24/06/49	G09	BLT
4407	G	Leaving Princetown platform + 1 coach for	??/04/51	G10	BLT

		Yelverton, loco GWR livery			
4408	-	Tondu shed yard, 57XX pannier tank, Collett coach, no OS steampipes	??/??/38	K21	G80
4408	-	Swindon ex-works, painted but not lettered	??/03/48	C60	GP3
4408	-	Tondu shed roundhouse, next to larger prairie	09/09/51	K22	G80
4409	-	St Ives by goods yard crane, some mixed trains of brake compos+/4/6 wheel stock	??/??/13	H04D	GC
4409	G	Wellington down bay platform, Craven Arms, ?4 coaches, clerestory & Collett	03/08/35	N41	G33
4409	G	Near Wellington, Craven Arms, 2 coaches van and van third, brake at coach junction	10/09/49	N42	G80
4410	-	St Ives loop, coaches in platform, open wagon on loop, shunting	??/09/32	H05D	G80
4410	-	Ex Swindon works, new OS steampipes curved drop end, Laira allocated, 1934 livery	??/09/36	C61	G80
4410	G	Carbis Bay, St Ives portion of Cornish Riviera Express	??/??/48	H06D	GW2
4410	G	Yelverton platform, B set coach, loading parcels, porter sitting Lyons Ice Cream box	??/??/53	G11	E211
4410	B	Princetown platform, driver topping up flange greaser reservoir	??/??/53	G12	G80
4410	G	Princetown, coaling from GWR LOCO coal wagon-bunker, signal box, loading gauge	??/??/53	G13	E211
4410	B	Between Ingra Tor & King Tor Halts, Yelverton-Princetown, 2 coaches ?b&c/GWR	23/04/55	G14	BLM
4410	G	Dousland platform, Yelverton-Princetown, ?2 coaches	02/07/55	G15	BIR
4410	B	Near Sheepstor & Burrator Halt, mixed train one coach, 2 vans +TOAD	05/07/55	G16	BLT
4410	G	Ingra Tor Halt, Yelverton-Princetown, ?2 coaches	05/07/55	G17	E211
4410	B	Burrator Halt platform, Yelverton-Princetown, one 57 foot Collett corridor brake coach	06/07/55	G18	NOS
4410	G	Dousland platform, Princetown, 1 b&c coach, signalman waits with electric train staff	??/??/55	G19	E211
4500	B	Helston platform, 3 coaches	??/??/51	H07	GWRB
4500	-	Gwinear Road, freight 2 BR open loaded sand. 4537 passing runround, both Penzance	??/??/53	H08D	GWL
4502	B	Clearbrook Halt, 4.30 pm Plymouth Millbay-Tavistock, ?6 clerestory coaches	21/06/38	G20	GWV
4502	Tail	Tetbury stn. Autocoach coupled.	??/??/50	C62	BLT
4503	G	Wadebridge platform, B set, front number high up on buffer beam	??/??/4?	H09	G76
4504	-	Hayle Harbour, open, oil tanks + TOAD	??/04/50	H10D	CRPS
4505	J	Hayle Harbour swing bridge, ESSO tank wagons from the wharf	??/??/56	H11D	G73
4506	A	Near Saundersfoot stn on 8.55 am Paddington-Tenby through + 5539 DH	29/05/37	L09	WWG
4507	-	Weston-Super-Mare, Locking Road platform, empty stock, Taunton, concertina coach	??/??/26	E12	G95
4507	B	Clifton Bridge stn, BTM-Portishead, 7 coaches	03/07/38	D07	G52
4507	G	Totnes platform, Bristol Division B set no 27	??/??/47	F79	APR2
4507	B	Swindon bay platform taking water	01/07/52	C63	GWY2
4507	-	Yeovil Pen Mill shed, inside with pannier tanks	??/08/53	D08	G2
4507	J	Near Maiden Newton for Bridport, B set	??/05/59	DW01	BBR
4507	-	Bridport shed with 4562 about to leave for	15/06/59	DW02	BBR

		last time on shed closure			
4507	B	Taunton platform inspection pit, water crane	12/05/62	E13	STW3
4507	K	Outside Yeovil Pen Mill shed by loop signal no front numberplate	??/08/63	D09	G2
4508	J	Bodmin General, Bodmin Road, loaded and sheeted china clay + TOAD each end	23/05/35	H12	GWW
4508	A	Penzance platform 2, stn pilot, shunters truck, Collett coach	??/???52	H13D	G62
4508	B	Near Coombe Junction, Looe-Liskeard, 2 coaches	10/07/55	H14	BLM
4509	-	Westbourne Park, empty coaching stock	??/??/2?	A33	GW2
4510	B	Bristol Bath Road shed with 4056 Princess Margaret	??/?6/52	D10	GP3
4511	-	Gloucester Horton Road shed yard, Shrewsbury/Ludlow allocated then	11/04/37	J51	G49
4513	G	Witney platform, Oxford, mainline city coach stock, parcels on platform, 81F shedplate	??/??/60	I62	G87
4516	K	Barnstaple Victoria stn, Barnstaple-Taunton freight, MICA, FRUIT, MINK, firebox windows	??/06/25	E14	TRU
4517	-	St Blazey shed yard, others same class and pannier tank in shed	??/??/34	H15	GC
4517	A	St Ives platform, CORNISH RIVIERA EXPRESS coach-board, Centenary brake	??/?8/36	H16D	GC
4517	B	Shunting wagons into Helston goods shed, wood MINK, opens, vans, coaches platform	19/06/38	H17D	GDG
4517	K	Near Lostwithiel china clay for Fowey Docks	??/??/50	H18	GWL
4518	G	Dovey Junction-Machynlleth up freight, ?30 wagons mostly vans, opens	11/05/49	P25	GDG
4519	B	Whitland, Pembroke or Cardigan branch working, ?FRUIT C first vehicle	??/??/50	L10	G96
4521	G	Outside Paddington awaiting further carriage empty stock duties	??/??/29	A34	ZEN
4522	G	Ebbw Vale platform, 10.03 am Aberbeeg, B set, milk churns on platform, Stephen's Ink	26/04/48	K23	GDG
4524	B	Launceston platform, Plymouth, 3 coaches	??/??/47	G21	G41
4524	G	Princetown platform running round coach, loco Laira allocated	??/??51	G22	BLT
4526	-	Wadebridge platform, Padstow-Bodmin Rd, B set GWR, loco BRITISH RAILWAYS	08/07/49	H19	G65
4526	-	St Blazey shed yard, BRITISH RAILWAYS lettering, often at Moorswater shed for Looe	??/??/49	H20	G96
4526	-	Bodmin General platform, signal box, 2 pm Wadebridge, B set NEWQUAY BRANCH	04/07/52	H21	GWRB
4526	K	St Dennis Junction, St Blazey/Fowey, ?20 loaded china clay+TOAD, 3635 banking rear	??/07/55	H22	TGM
4526	Tail	St Dennis Junction, running round PRC special, 3705 freight, Retew branch	01/10/55	H23	TGM
4526	G	Drinnick Mill, PRC special, 6 TOADs, taking water	01/10/55	H24	TGM
4526	K	St Blazey sidings, empty china clay wagons from Fowey Harbour	07/08/56	H25	SPI
4527	Tail	Bridport clean 1942 livery, plain bunker back	??/??/46	DW09	APR2
4527	B	Near Weymouth stn, single autocoach	??/??/51	DW03	G96
4527	-	Home Weymouth shed attention from fitter, 6328, next road	07/08/50	DW04	100
4528	B	Platform Wolverhampton LL waiting for train	??/??/25	M105	WMI
4529	B	?Bath Spa, local service in carriage siding, 4 wheel coach, small bunker, firebox windows	??/??/25	D11	G95
4530	-	Exeter shed yard, St Davids to rear,	10/07/38	F45	GWS

		autocoach No 93 parked			
4534	K	Plymouth North Road, transfer freight Tavistock Jnctn-Millbay-docks, ?20 wagons	27/03/37	G23	G95
4534	B	WSH, Hereford, 4 mixed coaches + CORDON, passing vinegar branch	08/08/39	J52	G50
4534	-	Near Cheltenham Malvern Rd stn, running light from St James to Malvern Road shed	21/05/48	J53	G96
4537	B	Aller Junction, Newton Abbot-Kingswear, 4 clerestory coaches, loco 1927 livery	31/07/34	F46	GWV
4537	G	Helston, corridor coach +1, loco on shed	??/??/55	H26D	GWL
4539	-	Wolverhampton Stafford Road Works, motion dismantled	??/??/35	M106	WMI
4539	G	Bridport platform, B set, 4562 on rear to remove fish van from arrival	??/??/51	DW05	BBR
4540	G	Gwinear Road signal box, token for Helston, B set + van	??/??/55	H27D	GWL
4540	-	Gwinear Road platform footbridge, shunting van and opens	??/??/59	H28D	G73
4541	K	Abergavenny down goods loop, banking duties, GWR livery and shedcode PPR	16/09/49	K24	NW3B GWS
4541	-	PontyPool Road shed, outside	06/04/52	K25	NW3B
4542	-	Princetown stn. Running round single coach	22/09/55	G24	BLT
4543	K	Liskeard platform 3, 4pm from Looe, B set coaches	08/05/36	H29	WWG
4544	G	Swindon Town up platform, ?B set, ?M&SWJ arrival	??/??/49	C64	G96
4545	G	Near Carbis Bay, DH,45XX, Cornish Riviera Express, 10 coaches	15/08/53	H30D	GC
4545	G	St. Ives branch 10 coach Cornish Riviera Express + another 45XX	??/??/56	H31D	GWL
4545	G	Alongside water tower St Ives shed	27/09/56	H32D	GC
4547	-	Brixham platform, Hackney Yard NA-Brixham, freight, brake van and 6 empties	18/10/48	F47	G85
4547	B	Bovey platform, B set	??/??/5?	F48	LLW
4548	B	Plymouth Millbay platform, 5.25pm Tavistock, 1 Collett, 3 clerestory coaches	26/06/35	G25	GWV
4549	F	Taunton freight yard, wood MINK, clean 1927 livery, 2 photos	??/??/30	E38	APR1
4549	Pilot	Abertafol, 8 coaches, 1 clerestory, 1 40 foot brake van, Dean Goods train engine B	??/08/37	P01	CAM2
4549	J	Towards St Blazey, loaded/sheeted china clays+2 vans, DH 4569, both bunker first	25/06/51	H33	BRF
4549	J	Near St. Blazey + 4569 DH, china clay, Ponts Mill, both bunker first	??/??/55	H34	CRPS
4549	B	Coming off Barmouth Bridge, Machynlleth-Barmouth, 2 coaches b&c	11/05/58	P02	NOS
4549	-	Loco frames, under overhaul, Wolverhampton Stafford Road Works	18/10/59	M107	G98
4549	C	Plymouth Friary (L&SWR), leaving with 9 brake-van tour, Yealmpton Branch, PRC	27/02/60	G26	YB
4549	A	St Erth, St Ives portion of Cornish Riviera Express, ?11 coaches, chocolate and cream double-headed with 4570	30/07/60	H35D	WES
4550	-	Kingsbridge platform, Brent, loco 1927 livery, coach panel lined	??/??/30	G27	KB
4550	K	Andover Junction stn, Southern Region mixed freight, opens and vans, ?30 wagons	??/??/51	C75	100
4551	-	Temple Meads Loco Yard signal box, next to 4000 gallon Collett tender	23/10/48	D12	G96

4551	G	Tidworth platform, B set for Ludgershall, loco GWR post war livery	07/08/50	C65	B13
4552	B	Luxulyan Valley, Par-Newquay, 3 coaches	09/07/55	H36	GW2
4552	K	Nanstallon branch, mostly china clay wagons, van and TOAD, skidding	??/??/5?	H37	ABL
4552	-	Retew, St Dennis Junction, level crossing light engine	??/??/5?	H38	GC
4552	G	Looe platform, Liskeard, train to harbour line to run round, 4 coaches, 1 b&c	25/07/57	H39	WS
4552	B	St Agnes platform departure, ?B set	??/07/59	H139D	AHS3
4552	-	Penzance engine shed yard, lined green livery, 4-6-0 County in background	09/04/60	H40D	G10
4552	G	Wadebridge, Bodmin, B set, SR T9 30313, Exeter. LSWR signal gantry	??/06/60	H41	SCP
4552	Tail	Shunting china clay hoods, Bodmin General	27/05/61	H42	COL3
4553	B	Torquay down platform, Newton Abbot-Kingswear, 5 coaches, 3 clerestory	??/??/25	F49	TC
4553	-	Carmarthen shed yard, Whitland allocated, another same class, pannier tank	??/??/51	L11	G96
4553	B	Between Christow and Ashton, B set b&c	07/04/58	F50	TVL
4553	B	Leaving Ide, B set one ?b&c	19/04/58	F51	TVL
4554	G	St Ives platform, B set+?1	12/08/36	H43D	GC
4554	G	Leaving St Ives near outer home signal, 6 coaches	??/?8/58	H44D	GC
4555	-	Friog, Manchester-Pwllheli towards Barmouth, mixed corridor coaches	28/07/51	P03	G16
4555	G	Coryton platform, Launceston-Plymouth, 2 coaches 1 corridor	23/06/62	G28	SPI
4555	B	Shaugh Bridge Platform, Plymouth-Launceston, 2 coaches, pagoda shed	29/09/62	G29	BLM
4555	B	Kemble, Swindon, test run before preservation purchase, Hawkesworth coach	??/08/63	C66	G16
4555	B	Merthyr shed yard, oiling round, SLS special train, short bonnet, 1927 livery	02/05/64	K26	G16
4555	B	Snow Hill platform 7, 5.25 pm Knowle & Dorridge, Leamington too far water-wise	??/06/64	M108	GDG
4555	K	Hatton, Bordesley Junction-Leamington, ?20 wagons	??/08/64	MD109	150G
4555	G	Ruabon, TRPS special, Towyn, waiting for train with 7827 Lydham Manor	26/09/64	P29	SWC
4555	-	25 detail photos in preservation, location ?DVR+1 Oswestry Works (1950s)	??/??/65	P26	G17
4555	G	Staverton Bridge, SDR, 6 coaches inc. auto	13/08/70	F74	GWM
4557	-	Swindon ex-works outside, Heavy General Repair, Whitland allocated, unlined black	15/08/54	C67	G97
4557	B	Glogue Halt, taking water, 2 coaches	09/06/60	L12	GW5
4557	B	Crymmych Arms for Whitland, ?B set plus one coach	28/04/62	L23	1162
4557	-	Crymmych Arms, from Cardigan 5 wagon freight, passing 1648 + 1 coach, 7.30 pm	31/05/62	L13	SPI
4557	B	Near Cardigan, single coach, starting signal	16/06/62	L14	WELP
4558	Tail	Outside Evesham shed with Dean Goods, Worcester allocated.	??/?6/36	J54	WMI
4558	B	Cardigan stn. ?3 coaches	30/07/60	L15	GWB
4559	-	Wadebridge platform, Bodmin Road, 3 coaches, LSWR T9 4-4-0 30709 from Padstow	??/??/54	H45	G65
4559	G	Bodmin General junction, B set + TOAD	??/??/55	H46	GWL
4559	B	Coombe Junction, Looe-Liskeard, 3 coaches, After loco run round, from signal box	04/07/59	H47	WS

4559	B	Near Bodmin general, Bodmin Road, 2 coaches	11/04/60	H48	GW1
4559	B	Boscarne Junction, Wadebridge-Bodmin Road, B set	??/06/60	H49	SCP
4560	-	Worcester shed yard, 1934 livery, sliding cab shutter, tall bonnet, ATC shoe	??/??/39	J55	G16
4560	B	Aberdovey up platform, b&c coach, Cambrian signal 'OFF', 25 mph speed sign	26/07/55	P04	CA2
4560	K	Criccieth-Portmadoc, freight from Pwllheli, 4 opens + others	??/07/59	P05	G97
4561	B	Gara Bridge home signal, Kingsbridge-Brent, 1 van, 1 bogie ?LNER parcels, 2 coaches	18/04/60	G29	KB
4561	K	Inside Kingsbridge shed, water tower, coal stage, gas lamp	??/??/60	G30	HIS
4561	B	Near Avonwick, Kingsbridge-Brent, 2 coaches, 1 van at rear	03/08/61	G31	KB
4561	B	Near Avonwick, Kingsbridge-Brent, 2 SR Utility vans, 1 coach	08/06/61	G32	KB
4562	G	Wadebridge platform, Bodmin Road, B set coach, GWR on tank sides, MEX in back	??/07/48	H50	G65
4562	G	Maiden Newton, gravity shunt of B set, 6982 Melmerby Hall on Weymouth-Westbury	10/10/50	DW06	BBR
4562	-	Bridport, on goods shed road, B set	??/??/5?	DW07	BBR
4563	G	St Ives platform DH another 45XX ?7 coaches	??/05/58	H51	G103
4563	K	Praze platform, Helston-Gwinear Road, B set plus other vehicles	??/??/60	H140D	AHS1
4564	B	Newton Abbot shed, inspection pit, raising steam	29/06/26	F52	G16
4564	-	Llyngwril up platform taking water, Swansea-Pwllheli, ?LMS coach, GWR signal 'OFF'	02/08/58	P06	CA2
4564	-	St Ives shed, shunting loco coal wagon	??/?6/59	H52D	G5
4564	G	Carbis Bay, St Erth-St Ives, 5 coaches	??/?8/59	H53D	LB
4564	A	Bugle stn, Carbis branch, PRC tour, DH 5531, 11 brake-vans only 1 TOAD	28/04/62	H54	TGM
4564	J	Gloucester Eastgate, 15+ 16T mineral wagons, Midland Railway signal box	09/03/64	J56	STW3
4564	-	Gloucester Central, ?9 wagons, 73053 in bay with Hereford train	28/08/64	J57	SPI
4564	J	Cinderford branch, Gloucester, ?7 oil tankers, ?10 loaded mineral, TOAD	28/08/64	J58	CL
4565	B	Newton Abbot shed yard with all updates, GWR LOCO COAL wagons in background	??/04/26	F75	G95
4565	J	St Austell, P-Way train, 3 or 4 plank opens, 2 TOAD, loaded wooden sleepers	23/09/51	H55	GDG
4565	B	Wadebridge platform, Padstow-Bodmin Rd, B set BR livery	19/08/54	H56	G65
4565	G	Looe, Liskeard, wharf loop, running round, 3 coaches in loop tight fit	??/?7/59	H57	LB
4565	B	Combe Junction for Looe, 3 coaches	15/08/59	H58	WES
4565	-	Under overhaul at Wolverhampton Stafford Road Works, 3 photos	18/10/59	M110	G98
4565	G	Grogley, 3.24 pm Wadebridge to Bodmin, B set coaches	10/09/60	H59	CRPS
4566	-	Hayle Harbour shunting open, near signal box. GWR bufferbeam number	??/??/50	H60D	GWL
4566	G	St Erth, St Ives bay, 70019 Lightning Cornish Riviera Express, Paddington-Penzance	19/04/52	H61D	CRPS
4566	G	North of Carbis Bay, St Erth-St Ives, B set	18/07/53	H62D	GC

4566	G	Carbis Bay, St Ives-St Erth, ?3 coaches+van	??/08/59	H63D	BLM
4566	-	St Ives sea siding light engine, ?running round, empty fish boxes in goods yard	11/09/59	H64D	G97
4566	-	Outside Newton Abbot ex-works, BR lined green, last loco out-shopped there	15/07/60	F53	SDN
4567	B	Shrewsbury platform 8, Severn Valley, 4 corridor coaches	21/07/54	N43 DET	NW1
4567	-	Laira shed under the hoist	??/03/60	G33	GWE
4568	B	Barnstaple Victoria stn, Barnstaple-Taunton, 2 clerestory and 1 Collett coach	??/06/25	E15	TRU
4568	B	Yelverton platform, Princetown, single b&c coach, platforms thronged 5 coach Plymouth	03/03/56	G34	E211
4568	Pilot	Burrator Halt, 6 coaches, 4583 train engine, last day of operations	03/03/56	G35	LLW
4569	K	Liskeard platform 3, for Looe, 3 coaches, ?B set +1	??/??/56	H65	G91
4569	-	Falmouth water tower and crane	??/??/47	H66D	GWY
4569	J	Towards St Blazey, loaded/sheeted china clays+2 vans, DH 4549, both bunker first	25/06/51	H67	BRF
4569	B	Wadebridge bay platform, Bodmin Road, ?mixed B set	13/04/54	H68	G65
4569	B	Causeland Halt, Liskeard-Looe, B set slope roof hut, 2 passengers	??/??/55	H69	MBL
4569	G	Kingsbridge main platform, Brent, B set	20/04/57	G36	ABL
4569	B	Bodmin Road, Bodmin General, 2 B set coaches	??/07/57	H70	SCP
4569	G	Grogley Halt, B set, Wadebridge to Bodmin Road	10/09/60	H71	COL3
4569	Tail	Cardiff General, ex-works lined green livery, station pilot, gantry by bridge over road	03/07/61	K27	G97
4569	B	Boncath, Whitland-Cardigan, 1 coach	18/08/62	L16	GWB
4569	Pilot	Boncath platform, 5 coaches last day Cardigan branch, train engine 4557 B	08/09/62	L17	BIR
4570	-	St Ives platform ramp, long passenger train	??/?8/55	H72D	G97
4570	G	Nancegollan platform, Gwinear Road-Helston, B set	19/10/56	H73D	G55
4570	-	Carbis Bay empty stock summer Saturday	19/08/61	H74D	COL3
4571	A	Fencote stn, SLS special last train	26/04/58	J70	GBLG
4571	A	Bromyard platform, SLS special, Bromyard to Leominster, taking water	26/04/58	J59	ABL
4571	A	Bromyard platform, SLS Special last train to Leominster, 6 coaches, thronged platform	26/04/58	J60	GWS
4571	G	Near St Ives, St Erth, 3 corridor coaches	12/06/59	H75D	GC
4572	B	Cheddar platform, Wells-Cheddar, ?B set, 5527 opposite platform + van, overall roof	??/??/5?	D61	G54
4573	B	Ledbury, Gloucester, 2 coaches one blood and custard	27/12/58	J61	SPI NOS
4573	B	Near Barber's Bridge, Gloucester-Hereford two coaches one blood and custard.	20/06/59	J62	WGW
4573	B	Kingham taking water, Cheltenham, no stock	??/?6/60	I63	MGW
4574	G	St Ives, running around coaches in platform	??/??/56	H76D	GWRB
4574	-	Falmouth goods shed, shunting 3 different vans into the shed	15/05/59	H77D	TGM
4574	-	Laira shed at the hoist	??/03/60	G37	GWE
4574	B	Padstow platform, Bodmin Road, B set	??/?7/60	H78	G65
4575	-	Truro shed yard, Falmouth and Chacewater-Newquay trains	21/08/27	H79	G95
4575	B	Criccieth, Pwllheli, ?3 coaches one war time brown livery	11/09/46	P07	G31

4575	B	Machynlleth turntable in motion	??/08/51	P08	100
4577	K	Torquay centre road, light, 82A shedplate	13/08/55	F54	GW4
4577	B	Helston platform, running around 3 coaches	21/06/58	H80D	GBLG
4577	B	Helston platform, Gwinear Road, ?3 coaches, vans in goods road, locospotters	??/??/59	H81D	SPI
4579	K	Snow Hill, Bordesley Junction transfer, 30? Wagons, Tyseley allocated.	07/09/34	M111	WWG
4581	G	Dawlish, 11 coaches including Dreadnought, four wheelers, Collett and Dean types	??/??/3?	F55	GW1
4582	B	Kingsbridge goods yard, cattle dock, shunting MEX, B set to Brent last job	??/??/47	G38	G85
4583	B	Burrator Halt, 6 coaches, 4568 pilot engine	03/03/56	G39	LLW
4583	K	Running into Plymouth North Road, light engine, vacuum hose unstored	??/04/62	G40	WSF
4584	-	Bodmin Road platform taking water, light engine	19/08/54	H82	G65
4585	-	Swindon shed yard, red background to numberplate, lined black large emblem	??/??/50	C68	G97
4585	G	Boscarne Junction, Wadebridge-Bodmin Road, Mixed, B set, LSWR Beattie 30585	19/08/53	H83	G65
4585	B	Looe, Liskeard, B set pulling past signal box to run round on wharf extension	29/09/59	H84	WS
4585	J	Crugwallins sidings, Burngullow, Drinnick Mill, sheeted open, vans, TOAD	??/??/59	H85	GC
4586	G	Cleobury Mortimer platform, Kidderminster-Woofferton, 2 clerestory coaches	11/05/38	N44	COL3
4586	B	Cheltenham St James platform, Gloucester or Kingham service, ?B set	02/06/52	J63	G96
4586	A	Gloucester LMS, Cheltenham Spa Express, Cheltenham-Paddington, 8 coaches+	??/??/5?	J64	SAL
4587	K	Brent goods yard, clean lined green livery, cycling lion emblem, ex Newton Abbot works	??/07/57	G41	SCP
4587	-	Crossover at Moretonhampstead stn running round B set, 2 photos in the book	25/07/57	F56	BLT
4587	B	Shepherds stn loop, 9.12 am Newquay-Truro, 5 coaches, 2 blood and custard	14/09/58	H86D	WES
4588	B	Perranwell platform, Truro-Falmouth 2+ coaches	??/??/55	H87D	GWRB
4589	B	Cardiff Queen St, 2.10pm Coryton-Cardiff Bute Road, 2 auto-trailers, AUTO 2 target	06/10/53	K28	CL
4590	B	Near Witham stn, Wells-Frome, B set	07/08/37	D13	G95
4591	B	Clearbrook Halt, 5.25 pm Plymouth Millbay-Tavistock, 4 coaches	21/06/38	G42	GWV
4591	Tail	Laira coal stage + ex-LMS brake van	24/05/63	G43	GWE
4591	-	Junction Yeovil Pen Mill to Yeovil Town, 3 coaches	30/05/64	D14	COL3
4591	-	Westbury shed coaling stage under chute	??/07/64	D15	GWE
4593	K	Abergavenny Monmouth Road stn, Pontrilas-Pontypool Road, ?20 wagons	??/??/58	K29	NW3B
4593	G	Pontypool Road carriage sidings	26/03/59	K30	NW3B
4593	B	Mithian Halt, 4.25 pm Truro-Newquay, 3 coaches	09/07/60	H88D	TDH
4593	Pilot	Ilminster, Taunton-Chard LCGB, 10 SR coaches, Pannier Tank 9663 train engine	16/02/64	E16	GBLG
4593	Pilot	Yeovil Pen Mill platform, 9663 LCGB Railtour, cash register signal, 4575 class in yard	??/02/64	D69	AHS4
4593	B	Montacute, Yeovil Pen Mill-Taunton, ?3 coaches	13/06/64	D16	BLS
4593	B	Hendford Halt, 2.10 pm Taunton-Yeovil Pen	15/06/64	D17	WES

		Mill, 2 coaches			
4594	D	Westbourne Bridge, empty stock, Target 8, sent new, 1927 + 2 others carriage duties	??/?9/27	A35	G95
4594	B	Snow Hill stn shunting carriages, Kidderminster allocated	03/09/47	M112	G39
4595	Pilot	Westbury stn, Wells, 12 LSWR coaches, 5549 train engine, WWII	??/??/4?	D62	W32
4595	B	Cheddar platform, Yatton bound, ?B set	??/??/61	D70	AHS2
4597	-	Witham bay platform, 1.30 pm Yatton, ?B set, overall roof, passengers and porter	05/08/57	D18	NOS
4597	B	Passing Truro shed, 3 coach Chacewater-Newquay service	??/09/57	H89D	GW6
4598	K	Royal Albert Bridge Saltash, local goods	18/07/38	H137	REF
4599	C	Paddington, Bishop's Lane Bridge, TOAD in 1927 livery in background	??/??/29	A37	APR2
4599	A	Machynlleth platform, Pwllheli prtn Cambrian Coast Express + headboard, 89C shedplate	??/07/56	P09	CA1
5500	G	Truro coal stage, coaled by gantry feed mechanism, 4-6-0 County in yard	??/04/56	H90D	G97
5500	B	Falmouth branch, ?3 coaches	??/??/57	H91D	GWL
5500	B	Falmouth Docks platform, 10.50 am Newquay-Falmouth, ?3coaches	17/05/59	H92D	TGM
5500	K	Shunting vans, CONFLAT underneath Perranwell signal box, SR, 16T mineral, LMS	20/05/59	H93D	WS
5500	B	Penryn platform, ?3 coaches, ?3 passengers	??/??59	H141D	AHS3
5501	K	Newton Abbot shed, outside	??/05/57	F57	GWE
5502	K	Par platform running light, westward, used banking Newquay, trains Bodmin & Looe	25/08/48	H94	G96
5502	B	Padstow platform, 9.08 am Bodmin Road, B Set	07/06/49	H95	GWS
5502	B	Looe platform, Liskeard, 3 coaches	16/06/58	H96	GWRB
5503	G	Torquay stn, centre road, packed platform, lined green livery	??/?8/57	F58	MBL
5504	-	Taunton shed yard with Star, Minehead and Yeovil duties, 1927 livery	22/07/34	E17	G95
5504	J	Crowcombe, Minehead-Taunton, ?11 wagons, mostly vans, opens	26/02/60	E18	NOS
5506	G	Stapleton Road, from Keynsham, 10 coaches	??/??/35	D63	W32
5506	K	Plymouth stn approach, pilot, 1010 County of Caernarvon on Cornishman, 31830 SR freight	04/07/57	G44	GW1
5508	B	Wells (Tucker St), Yatton & Witham, B set, taking water, Westbury 82Dshed plate	22/10/52	D22	G97
5508	B	Pensford Viaduct, Bristol-Radstock, B set	14/03/55	D20	GW2
5508	B	BTM main outer platform, for Frome, B set, loco unlined black livery	07/07/56	D21	BIR
5508	G	Helston platform, 3.30pm mixed, Gwinear Road, van + B set	23/05/62	H97D	GWS
5508	G	Uxbridge Vine Street platform, LMS & BR full brake + FRUIT D	10/07/64	B47	G50
5509	B	Swindon Junction up platform, ?Westbury, B set GWR livery	19/06/48	C69	G61
5509	B	Swindon Junction down bay platform 3, ?M&SWJ to Swindon Town	??/??/56	C70	G97
5510	B	Barmouth for Aberystwyth, 4 coaches	??/??/56	P24	GWX
5511	K	Plymouth Laira yard	22/10/59	G45	G97
5514	-	Chipping Norton stn terminus, running round Kingham train	07/06/58	I66	BIR
5515	-	Truro up goods loop, water crane, taking water, LNER van coupled	??/??/55	H98	G97

5515	B	Chacewater platform, 5.58 pm Chacewater-Newquay, 4928 Gatacre Hall PZ-Manchester	??/08/59	H99D	TGM
5515	B	Par, for St Blazey shed, running light	??/06/60	H100	SCP
5516	-	Inside Pontypool Road shed, 5224 outside, 2-8-0 and LMS tender also present	23/05/54	K31	G70
5517	Pilot	Cemmes Road area, LMS excursion Leicester-Aberystwyth, 10 coaches, Cambrian Jones Goods 893, A	06/08/38	P11	CAM2
5517	A	Near Barmouth station Cambrian Coast Express with headboard, Pwllheli portion	??/??/58	P12	GWX
5518	-	Bridgnorth platform, Shrewsbury-Kidderminster, blood & custard coaches	24/07/54	N45	GW2
5518	-	Churchdown stn, Cheltenham-Gloucester, chocolate and cream coach	30/10/63	J65	STW3
5519	G	Bodmin Road curve, Bodmin General, B set	??/??/47	H101	G65
5519	-	Approaching Bodmin Road, Bodmin-Padstow, van 3rd+B set	17/05/56	H102	G65
5519	-	Passing Moorswater shed + TOAD	16/06/58	H103	GBLG
5519	-	Meledor Mill, shunting china clay hoods	20/06/58	H104	GBLG
5519	-	St Dennis Junction, Par-Newquay, light engine, with 4294, signal box, water crane	28/06/58	H105	ABL
5519	K	St Dennis Junction, Fowey TOAD + china clay empties with 4294 DH	??/06/58	H106	G70
5519	G	Newquay platform 1, 3.20 pm Chacewater, 2 corridor coaches, Hawkesworth coach alone	20/05/59	H107D	TGM
5521	B	Hendford Halt, B set, Taunton-Yeovil Pen Mill	11/08/39	D23	WWG
5521	B	Bodmin Road loop platform, 12.20 pm Wadebridge, B set, water tower and cranes	10/05/58	H108	BLM
5521	K	Taunton yards, detail photos	23/10/59	E19	G97
5522	G	Minehead platform 1, Taunton, B set + clerestory	07/08/35	E20	G95
5523	-	Bristol Bath Road shed, outside, collision damaged, BRITISH RAILWAYS lettering	17/04/49	D24	G96
5523	G	BTM for Portishead, 2 B set coaches	??/??/56	D25	GSS
5524	B	Bentley Heath loops, Snow Hill-Leamington, 'Birmingham' B set of four coaches	??/??/28	M113	G95
5524	G	Ledbury platform, Ledbury-Gloucester, Van third, Lav composite, van third coaches	??/02/40	J66	G96
5524	B	Fairbourne platform, 2 pm from Barmouth, ?coaches, empty bottle milk crates to load	22/06/53	P13	GWS
5524	B	Cambrian coast, van + coaches	??/??/55	P14	GWU
5524	B	Wyndham Pits signal box, Nantymoel branch, 3 auto-trailers	03/05/58	K43	GBLG
5524	B	Dulverton, Exe valley platform, 2 coaches + van, Tiverton-Exeter	??/08/59	E21	GW4
5525	-	Sorley Tunnel, Brent-Kingsbridge, ?B set	??/??/61	G46	KB
5526	B	Middleway Crossing, St Blazey, Par-Newquay, 3 coaches	05/07/55	H109	TGM BLM
5527	B	Box Tunnel, west portal, Swindon-Bristol, 3 coaches, distant signal OFF	??/??/47	D26	SCE
5527	B	Outside Frome shed, non-standard water column, fire devil	29/03/48	D27	G96
5527	B	Box Tunnel, Chippenham-BTM, B set + another coach	??/??/49	D28	G95
5527	B	Yatton shed outside, early Clevedon freight, Wells and Frome branch trains	25/05/53	D29	G96 BLM
5528	G	Yatton 2 bay platform, Wells & Witham branch, ?3 coaches	??/??/55	D30	G97
5528	B	Congresbury, Wells-Yatton, 3 coaches blood	??/04/57	D31	G15

		and custard livery, W4907W			
5528	A	Pensford Viaduct, RCTS special, piloted 3440, 7 coaches mostly blood and custard	28/04/57	D32	GWRB
5528	B	Bath Green Park (S&DJR) 3 coaches - Bristol	??/??/5?	D33	LLW
5529	G	Sea Mills, BTM-Avonmouth, 4 mixed coaches, 1 clerestory	??/?6/34	DS14	100
5529	-	Barry shed yard. Brought there for push-pull work with two other 45XX class engines	23/05/54	K32	G96
5530	B	Christow platform, four coaches, passing other corridor coaches, last day, Teign Valley	07/06/58	F59	TVL
5531	B	Near Marsh Mills, 6.10 pm Plymouth-Launceston, 4 mixed coaches	19/08/36	G47	GWV
5531	B	Marsh Mills platform, Plymouth, ?3 coaches+ 1 clerestory, passing 6 coach train	29/03/37	G48	G41
5531	B	Tavistock South platform, Plymouth, 2 coaches, 1434 + autocoach at other platform	??/?6/58	G49	SPI
5531	A	Perranporth goods shed, Chacewater-Newquay, PRC, BR brakevans	28/04/62	H110D	BLM
5532	-	Laira original coal stage shunting wagons	??/02/62	G50	GWE
5533	G	Moretonhampsted water crane adjacent shed and signal box, running round after	??/??/55	F60	BLT
5533	B	Kingsbridge taking water, B set in platform, shed coal wagon	??/08/56	G85	AHS1
5533	B	Brent stn approach, Kingsbridge branch, B set	28/08/57	G51	EGW
5533	K	Kingsbridge platform, running round, vans in loop	15/04/58	G52	KB
5533	B	Newton Abbot platform 4, last train of all, Teign Valley Line, 83A shedplate	07/06/58	F61	TVL
5533	G	Gara Bridge, Brent-Kingsbridge, 1 b&c corridor coach, 1 other, 2 green camp coach	16/06/58	G53	E222
5533	B	Truro, Falmouth bay platform, 5.15 pm Truro-Falmouth, ?B set	15/05/59	H111D	TGM
5533	B	Perranwell platform, Truro-Falmouth, B set, vans in goods yard	20/05/59	H112D	TGM
5534	G	?Swindon assisting load of Churchill Tanks in World War II	??/??/41	C71	ADW
5534	B	Abergwynfi platform, Bridgend, 2 coaches	27/08/59	K33	TDH
5535	G	Cheddar, Witham-Yatton, B set coaches	07/05/36	D34	GWY
5536	-	Swindon shed, towing 6015 King Richard III, fireman shovelling ash under drivers for grip	11/09/55	C72	SGW
5536	B	Dunsford Halt, Exeter, ?B set b&c	01/03/58	F62	TVL
5536	-	Heathfield platform, 3 coaches, last day of operation, Teign Valley Line	07/06/58	F63	TVL
5536	B	Brislington, BTM-Frome, B set	22/05/59	D35	BLS
5536	B	Brislington, Frome –BTM, B set	24/10/59	D36	GWSB
5536	-	Truro stn, from Falmouth, ?B set, BR Class 22, D6301&D6302, Newton Abbot-Penzance	??/??/59	H113D	TGM
5537	K	Chacewater, St Blazey-Drump Lane goods, 13? wagons	??/??/35	H114D	GWL
5537	G	Truro turntable apparently static	??/??/57	H115D	100
5538	-	Kingham platform, Stow–on-the-Wold then Cheltenham, loco GREAT WESTERN, 1927	??/??/49	I64	BCR
5538	B	Near Newent stn. Ledbury service, two b&c coaches	23/08/58	J67	WGW
5539	A	Near Saundersfoot station on 8.55 am Paddington to Tenby through with 4506	29/05/37	L18	WWG
5539	K	Bovey platform, Moretonhampstead-Newton Abbot goods, ?11, open, vans TOAD	??/??/54	F64	G84

5540	G	Stapleton Road, Avonmouth, B set	??/??/36	D37	W32
5540	-	Approaching Wanstrow stn, East Somerset Railway, ?1 coach	??/07/55	D38	BLM
5540	B	BTM platform ?B Set coaches	04/08/57	D39	GWSB
5540	B	Black Rock Halt, between Portmadoc and Criccieth, down Pwllheli, 4 coaches	07/07/60	P15	G74
5541	B	Bathford Halt platform, Chippenham-Bath-Bristol, Dean clerestory coach	13/04/34	D40	G95
5541	G	Dovey Junction, from Barmouth inland, 9012 in adjacent platform taking token	??/?8/55	P16	E224
5541	A	Dovey Estuary, for Dovey Junction Pwllheli portion Cambrian Coast Express, 4 coaches	28/03/59	P17	BIR
5541	B	Launceston platform o/s signal box, Plymouth, 2 coaches	02/05/61	G54	G17
5541	B	Riverford Viaduct, 3.05 pm Plymouth-Launceston, 2 coaches, 1 blood and custard	10/05/61	G55	150G
5541	-	Horrabridge, Launceston-Tavistock J goods, CONFLATS, SR van, tanker, LMS van, ?13 wg	07/07/61	G56	G20
5541	K	Lydford GW platform, Launceston-Plymouth, CONFLATs and vans	03/04/62	G57	GBLG
5542	-	Yeovil Pen Mill Junction, station pilot	10/07/56	D41	GWJ
5542	A	River Dart embankment, Engineer's saloon W80976, loco formerly auto tablet catcher	26/08/57	F65	EGW
5542	-	Minehead shed, inside	23/08/59	E22	GWE
5543	B	Taunton platform 2, Taunton-Chard Junction, B set + war time brown Collett coach	??/??/47	E23	G32
5543	B	Bishops Lydeard, Minehead-Taunton, 4 coaches	26/02/60	E24	NOS
5544	B	Tavistock platform with freight mostly vans, passing same class on passenger train	23/06/62	G58	GW4
5545	G	Cymmer Afan, Bridgend-Abergwynfi, Autocoach leading, 2 coaches trailing	??/??/55	K34	FOR
5545	A	Barnwood, Gloucester ex-LMS signals for Cheltenham	??/??/64	J68	GW5
5546	B	Severn Beach platform, BTM, ?4 coaches	??/??/50	DS15	GWRB
5546	G	BTM platform ?B Set coaches	04/08/57	D42	GWSB
5546	-	Perranporth platform, 4.39 pm Chacewater-Newquay, DH 5539, 5515, Newquay-Chacewtr	03/08/59	H138D	TGM
5546	-	Gwinear Road sidings, shunting, TOAD vans and opens, 4564 on K lamps	09/04/60	H116D	G73
5546	-	Llanglydwen, Whitland-Cardigan, DH 4575 class, other 4575 held up by sheep on line	??/??/60	L19	FOR
5547	B	Yatton platform, BTM local, Bow-ended B set coaches, 6553 dia E129	??/09/47	D43	G96
5547	G	Mwyndy Junction near Llantrisant, SLS special, pair of autocoaches	13/07/57	K35	GW6
5548	G	Toller platform, Bridport branch, B set	31/03/56	DW08	BBR
5548	B	Washford platform, Minehead-Taunton, ?3 coaches	??/??/61	E25	G97
5548	G	Taunton platform, Minehead – Yeovil, ?4 coaches	??/??/62	E26	GSS
5549	Pilot	Westbury stn, Wells, 12 LSWR coaches, 4595 pilot engine, war time	??/??/4?	D44	W32
5549	B	Cardigan platform, Whitland, ?2 coaches, large amount of parcels being loaded	09/05/58	L20	SLI NOS
5550	B	Narberth platform, for Whitland, staff exchange, signaller on platform, SM, pass	30/07/58	L22	AHS4
5551	B	Paignton platform, for Newton Abbot, 4 coaches, 2 Dean, 2 Collett, 3rd class only	10/09/46	F77	100

5551	-	Ex-works ?Hackney Yard, Newton Abbot, light engine, lined green, 83A shedplate	12/04/59	F66	CL
5551	B	Luxulyan Valley, 2.40 pm Par-Newquay, ?6 coaches, 8702 banking at rear	08/08/59	H117	TGM
5552	-	Leaving Perranporth platform, 1.35 pm Newquay-Truro, 1894 style platform seats	20/05/59	H118D	TGM
5552	-	Leaving Chacewater platform, Truro, coach with CHACEWATER small destination board	??/??/59	H119D	TGM
5552	G	Falmouth Platform, Truro, 3 coaches, 1 B set, 1 corridor full brake	??/06/60	H120D	SCP
5552	J	Newham Wharf Truro, shunting, TOAD, BR brake van, vans, crane, river, cathedral	20/07/60	H121D	TGM
5553	B	Sandford and Banwell, from Wells, B set	28/08/58	D66	AHS1
5554	G	Clifton Down-BTM at Stapleton Road, 4 different corridor coaches	??/??/33	D45	W30 G61
5554	B	Axbridge near Cheddar, 7 pm Wells-Yatton, B set + 1 coach	04/07/51	D46	GWV
5554	B	Thingley Junction & Chippenham, Westbury – Swindon local, 2 coaches	??/?6/61	D47	COL3
5556	G	BTM, Radstock-Frome, clerestory coach	??/06/35	D48	G95
5556	B	Abergwynfi signal box, Bridgend, 3 coaches, coal train departing in distance	02/08/51	K36	GDG BLM
5556	J	Machynlleth shed with 9017	??/??/56	P18	GWM
5556	B	Dovey Junction platform, ex-Aberystwyth, heading east, ?4 coaches	13/08/59	P19	CA2
5557	B	Newton Abbot stn. Platform 5, Collett toplight coaches 5?	??/??/31	F67	W30
5557	K	Bodmin Road – Lostwithiel for Fowey docks, sheeted china clay opens and 2 brake vans	??/??/56	H122	GC
5557	G	Mitchell & Newlyn Halt, 5.52 pm Newquay - Chacewater	30/06/59	H123D	CRPS
5557	B	Bodmin Road, Bodmin General, ?B set, up main line ?Grange departing	??/?8/59	H124	G65
5557	B	Par, Newquay platform, 3 coaches, B set + non-corridor, loco unlined green	??/06/60	H125	SCP
5558	G	Brent loop platform, Kingsbridge, 2 coaches, 1 b&c	??/06/58	G59	KB
5558	-	Run round loop by Kingsbridge goods shed, light engine, mixed train-Brent, B set in bay	05/07/58	G60	G85
5558	B	Between Avonwick and Brent, Kingsbridge, 3 coaches 1 LMS	16/08/58	G61	KB
5558	B	Brent junction, Kingsbridge, 2 coaches 1 b&c + 2 vans, ?1FRUIT, 1SR	05/08/59	G62	KB
5558	G	Gara Bridge platform, Kingsbridge-Brent, ?2 coaches, past 5573 opposite direction	29/08/59	G63	KB
5558	B	Kingsbridge platform, 10.57 am to Brent, well -kept gardens whitewashed edging stones	05/08/60	G64	KB
5559	B	Portishead station (pre-1954), BTM, ?3 blood and custard coaches	??/??/51	D49	GWRB
5559	B	Winscombe platform, Yatton bound, B set, ?7 passengers plus staff	25/08/58	D67	AHS2
5560	G	Topping Patchway bank, 6 coaches	??/??/38	DS16	100
5560	B	Nantymoel, Tondu, 2 odd auto-trailers	14/08/54	K37	STW3
5560	A	Manorbier, 12.5 pm Pembroke Dock-Paddington, 7 coaches, 7318 pilot.	12/09/59	L21	TDH
5560	-	Tavistock South platform-Plymouth NR, propelling two autocoaches, autofitted	??/??/60	G65	E220
5560	B	Tavistock South platform-Plymouth NR, autocoach W228W	07/07/61	G66	G17

5561	G	Near Mells Road stn, BTM to Frome via Radstock, North Somerset Line, B set	??/?5/38	D50	G95
5561	B	BTM, local, 1st coach blood and custard, Castle, Merchant Venturer adjacent	??/??/57	D51	WSF
5562	-	Newquay platform 3, Chacewater, ?coaches, platform 1 5519, Par, 2 coaches	??/05/52	H126D	BLM
5562	B	Perranwell, for Falmouth, B set coaches	??/10/58	H127D	CRPS
5562	G	Goonbell Halt, Newquay-Chacewater, 3 coaches	14/08/59	H128D	BLM
5562	G	Mount Hawke Halt, 4.35 pm Newquay-Truro, 3 coaches, Pagoda shed, oil lamps	10/07/61	H129D	TGM
5563	B	Taunton 1 platform, down relief, local, 4 coaches, loco Yeovil allocated	27/08/55	E27	G97
5563	B	Martock platform, Yeovil-Taunton, 4 coaches, MEX in yard, 8 passengers on platform	26/07/58	D52	BLM
5563	B	Yeovil Pen Mill platform 1, ?B set for Castle Cary, corridor stock in platform 2, passngrs	26/08/58	D68	AHS4
5563	-	Durston stn for Yeovil + TOAD	??/06/62	E28	GSS
5564	B	Twerton Tunnel, Bristol-Swindon, 7 coaches	??/??/55	D53	GSS
5564	B	Kemble, shunting corridor coach on Cirencester loop, railbus W79976 in platform	25/11/61	C81	E214
5564	K	Uxbridge High Street goods yard, vans, 16T mineral, LMS brake van, coal staithes	??/??/64	B47	G1 TFL
5565	G	Bristol-Portishead, B set + clerestory coach	??/??/35	D54	W30
5565	G	Near Shepton Mallet, Witham-Yatton, B set	17/03/36	D55	G95
5565	B	Avon Gorge, Bristol-Portishead, B set	??/?7/54	D56	100
5565	B	Penhelig tunnel, freight, ?wood MINK	??/??/59	P31	0362
5565	B	Black Rock Halt, between Portmadoc and Criccieth, down Pwllheli, 4 coaches	07/07/60	P20	G74
5565	-	Stored at Machynlleth shed prior to withdrawal, Ivatt 'Mickey Mouse' in shot	10/09/60	P21	STW3
5566	Tail	Stoke Gifford, reversing workers train of 8 mixed coaches	??/??/3?	DS17	W32
5567	B	Launceston platform arrival, van+2 coaches, ?Pannier and coach in opposite platform	??/?6/57	G67	G17
5568	G	Senghenydd platform, Cardiff (Queen Street) ?2 coaches, former Rhymney Railway	21/05/55	K38	STW3
5568	B	Bickleigh platform, Launceston-Plymouth, 2 auto-trailers	03/04/62	G68	ABL
5569	B	Tavistock South platform, Plymouth, 2 ex-LSWR coaches	10/10/53	G69	WSF
5569	K	Yeovil Pen Mill Junction, single full brake, lettered bufferbeam	??/??/57	D71	AHS4
5569	B	Lydford stn, for Plymouth North Road, 2 coaches	??/??/60	G70	SPI
5569	B	Lydford stn, B set, LSWR stn. in shot	??/??/60	G71	LLW
5569	G	Tavistock South platform, Launceston, 2 auto-trailers	??/??/60	G72	ALL
5569	B	Lifton stn, Launceston-Plymouth, ?3 coaches	03/04/62	G73	GBLG
5569	B	Tavistock South platform, taking water	03/04/62	G74	GWRB
5569	B	Mary Tavy and Blackdown platform, 2 coaches, 3 passengers on platform	??/04/62	G75	GWRB
5569	B	Coryton Halt (Cornwall) platform, Launceston-Plymouth, 2 coaches	03/04/62	G76	ABL
5569	-	Swindon roundhouse road, 9680 and BR 9F 2-10-0 in background	??/?6/63	C73	G97
5570	K	Friog shelter, Portmadoc-Machynlleth, DH Dean Goods 2569, MEX, opens	21/08/36	P22	CA2

5570	F	Portmadoc, am coast line goods, passing 9015 in loop	29/06/57	P23	GW6
5570	-	Swindon stock yard, with 9604, 3842, 4-6-0 County and others stored and withdrawn	??/?3/63	C74	G71
5571	-	Christow platform, light engine, TOAD & LMS open in yard	??/??/30	F68	TVL
5571	A	Newton Abbot platform, Torquay, elderly mixed Dean coaches	10/08/32	F69	G95
5571	G	Taunton station with 2.15 pm from Yeovil Pen Mill, B set coaches	14/05/36	E29	WWG
5571	B	Crowcombe platform , Minehead, 2 coaches + other vehicles	??/?5/60	E30	BLS
5571	B	Donyatt Halt, Taunton – Chard Central, B set, 2.50 pm service	01/09/61	E31	LLW 1062
5572	B	Wolverhampton Stafford Road coaling stage Kidderminster allocated, SVR, Worcester	11/09/34	M114	WWG
5572	G	Maerdy platform, Porth, 2 coaches last autocoach	??/04/54	K39	GWRB
5572	G	Senghenydd platform, Bute Road Cardiff, 2 auto-trailers, Auto Duty No 2	??/??/55	K40	G97
5572	G	Tavistock South platform, 1.25 pm from Saltash, 2 coaches	08/08/61	G77	WES
5572	B	Marsh Mills platform, Plymouth-Tavistock, 1 autocoach	29/08/61	G78	LLW
5572	G	Launceston platform, LSWR water crane, 2 coaches	21/10/61	G79	STW3
5573	G	Perranwell platform, Truro-Falmouth, pair of auto-trailers	17/08/36	H130D	G95
5573	-	Gara Bridge platform, Brent-Kingsbridge, camp coaches washing line, 5558 up train	29/08/59	G80	KB
5573	A	Gara Bridge-Avonwick, Paddington, 6 coaches for 5029 @ Brent, 14 coaches total	06/08/60	G81	TDH
5573	B	Kingsbridge outer advanced starter signal, Kingsbridge-Brent, SR Utility van 1 coach	03/06/61	G82	KB
5573	G	Gara Bridge home signal, Kingsbridge-Brent, B set	??/??/61	G83	E222
5573	-	Moorswater shed, outside by water column	02/09/61	H131	COL3
5573	-	Totnes station yard, shunting fitted MINK van XP, mineral wagons in background	19/05/62	F70	GWS
5574	B	Gloucester Central centre roads to up main, empty stock	??/??/52	J69	G97
5574	G	Gilfach Goch colliery platform, SLS special, 2 auto-trailers, ?30+ coal wagons and mine	13/07/57	K41	BLM
5574	G	Porthcawl platform, 2 autocoaches, from Tondu, passengers under awning	??/07/58	K44	AHS4
3902	-	Swindon, photographic grey, saturated boiler, no top feed, firebox portholes	??02/07	C82	APR1 APR2
3902	B	Leamington platform, coupled clerestory coach, garter crest livery	07/05/11	MD01	G57
3903	-	Tyseley shed, garter crest livery	28/08/13	M02	WMI
3904	B	Snow Hill platform 4, coupling up to Stourbridge, Dudley or Wolverhampton	26/09/26	M03	G91
3904	E	Centre track Snow Hill, 1922 livery, LMS 3 plank wagon.	??/??/29	M04	WMI
3904	-	Swindon works, dead	29/10/33	C01	GWY2
3908	-	Tyseley shed works, under repair	??/??/10	M05	150G
3908	-	?Stourbridge Junction, loco yard	??/??/30	N01	GWY
3911	-	Tyseley shed works, under repair	??/??/10	M06	150G

3916	G	Snow Hill, south end middle road, light engine, garter crest, copper capped chimney	??/??/09	M115	APR1 APR2
3916	B	Leamington stn, light engine ?running round.	08/05/11	MD07	G59
3920	C	Centre road Snow Hill, 1927 livery, 4 wheeled coach	??/??/25	M08	WMI WML
3920	A	Stourbridge Junction, Birmingham, Dean clerestory coaches ?4	??/??/2?	N02	GW1
3920	-	Tyseley shed yard, 1927 livery, close coupled clerestory suburban stock in background	??/??/29	M116	APR1 APR2

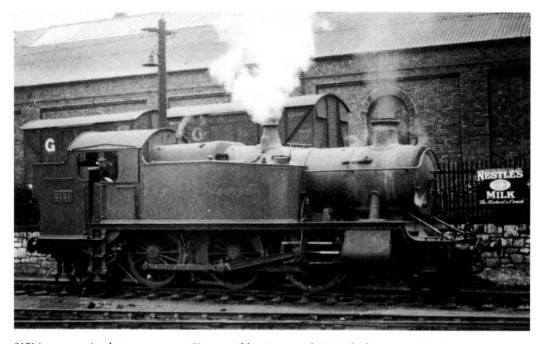

3151 is seen resting between turns at Newton Abbot in around 1930. The loco is in 1920s livery as are the wood MINKs behind. The headcode is for a pickup goods but this red route engine would not usually be going down any branch lines other than Kingswear and suspect it was primarily used on banking duties. MAP F. (Great Western Trust)

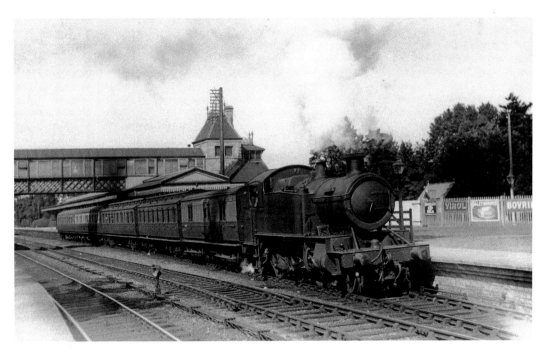

3152 with its train of Collett and Dean coaches waits at the Down platform for Paignton and Kingswear at Torquay in the summer of 1934. The loco has acquired an AWS shoe underneath the front bufferbeam from around 1930. MAP F. (Great Western Trust)

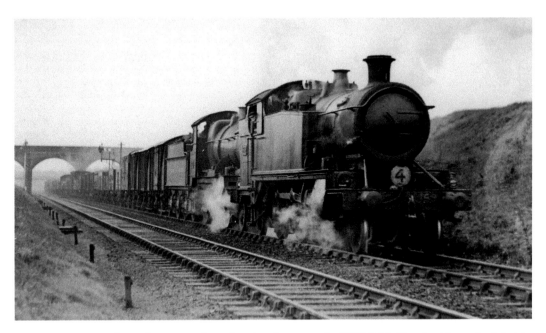

3159 emerges from the Severn Tunnel and assists an early 43XX 2-6-0 Mogul with a mixed freight towards Pilning station in around 1932. Target 4 duty required the loco to be detached at Pilning, reattached at the rear of the train and then push the freight the remaining distance to Patchway station, whereupon it would be detached once more and await further work. MAP DS. (Great Western Trust)

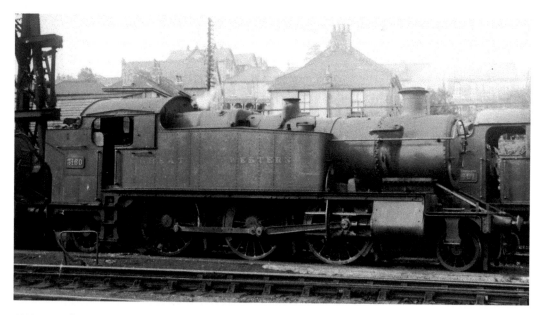

3160 is work-stained and weary-looking near the hoist at Plymouth Laira depot in around 1929. A copper-capped chimney as well as most of the modern features, except it still has a square drop end and no AWS gear yet. It has had over twenty years of service and would add more than that before withdrawal in July 1953. Small Prairie cousin 4401 is in the rear and had spells at St Blazey depot around this time. MAP G. (Great Western Trust)

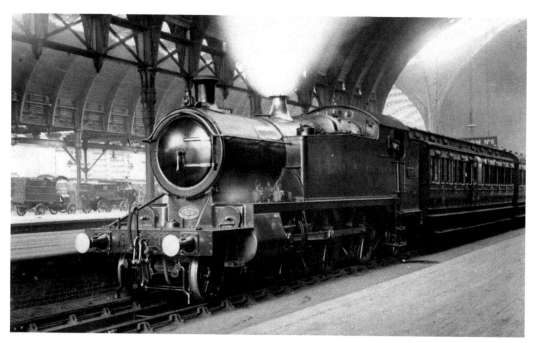

3160 and Dean clerestory coaches await departure from Platform 6 at Paddington in 1907, some twenty years before the previous figure. The loco has a plain cast-iron chimney, works plate on smokebox saddle and swan-necked vacuum pipe, but was the first engine to be built with smokebox struts. It also has brake rigging outside of the first four driving wheels. MAP A. (Great Western Trust)

Index of Maps Used for the Table

Although the maps depict the GWR lines by route availability colour, the double-red routes of the King Class are not defined. Dotted routes where locomotives of that colour are permitted to run at reduced speed, usually 20 mph, are included.

Index	Description of Area Covered
A	Paddington to Old Oak Common
B	Acton to (Reading) and West Wycombe
C	Swindon, M&SWJR and Reading
D	Bristol, North Somerset, Bath
DS	North Bristol, Severn Tunnel, Patchway, Pilning, Filton
DW	Weymouth, Bridport and Abbotsbury branches
E	West Somerset, Taunton, Bridgwater, Wiltshire
F	Exeter, Teign Valley, Ashburton, Moretonhampstead, Torbay, Kingswear
G	Plymouth, Launceston, Tavistock, Plympton
H	Cornwall (excluding West Cornwall)
HD	West Cornwall
I	Princes Risborough, Oxford, Banbury, Kingham, Chipping Norton
J	Cheltenham, Gloucester, Hereford, Worcester
K	South East Wales, Chepstow, Newport, Cardiff, Bridgend, Porthcawl
L	South West Wales, Llanelli, Carmarthen
M	Wolverhampton Low Level, Birmingham, Tyseley
MD	Leamington Spa, Hatton, Stratford upon Avon
N	Shrewsbury, Stourbridge, Dudley, Wellington, West Midlands
ND	Shrewsbury station and environs
P	Cambrian Coast Lines, Dovey Junction, Aberystwyth, Pwllheli, Machynlleth
Q	Chester, Wrexham, The Wirral, Crewe

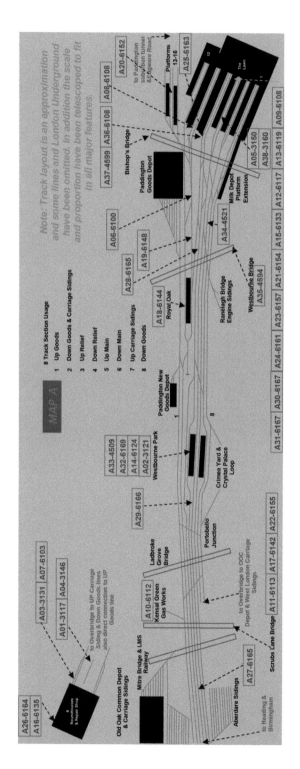

MAP A

Note: Track layout is an approximation and some lines and London Underground have been omitted. In addition the scale and proportion have been telescoped to fit in all major features.

8 Track Section Usage

1 Up Goods
2 Down Goods & Carriage Sidings
3 Up Relief
4 Down Relief
5 Up Main
6 Down Main
7 Up Carriage Sidings
8 Down Goods

A01-3117 | A04-3146
A03-3131 | A07-6103
A26-6164
A16-6135

A10-6112
Kensal Green Gas Works
Ladbroke Grove Bridge
Mitre Bridge & LMS Railway
Old Oak Common Depot & Carriage Sidings
to Overbridge to UP Carriage Siding & Down Goods lines also direct connection to UP Goods line

A27-6165
Aberdare Sidings
to Reading & Birmingham
Scrubs Lane Bridge | A11-6113 | A17-6142 | A22-6155
to Overbridge to OOC Depot & West London Carriage Sidings

Portobello Junction
Crimea Yard & Crystal Palace Loop
A29-6166
Westbourne Park
A33-4509
A32-6169
A14-6124
A02-3121

Paddington New Goods Depot
A18-6144
Royal Oak
A28-6165
A19-6148
Ranelagh Bridge Engine Sidings
Westbourne Bridge
A35-4594
A34-4521

A06-6100
Milk Depot Platform Extension
A05-3150
A38-3160
A13-6119 | A09-6108
A12-6117
A15-6133 | A21-6154
A23-6157 | A24-6161 | A30-6167 | A31-6167

Bishop's Bridge
Paddington Goods Depot
A37-4599 | A36-6108 | A08-6108
A20-6152
A25-6163
to Paddington subway/van tunnel & Edgware Road
Platforms 13-16
12
The Lawn
1

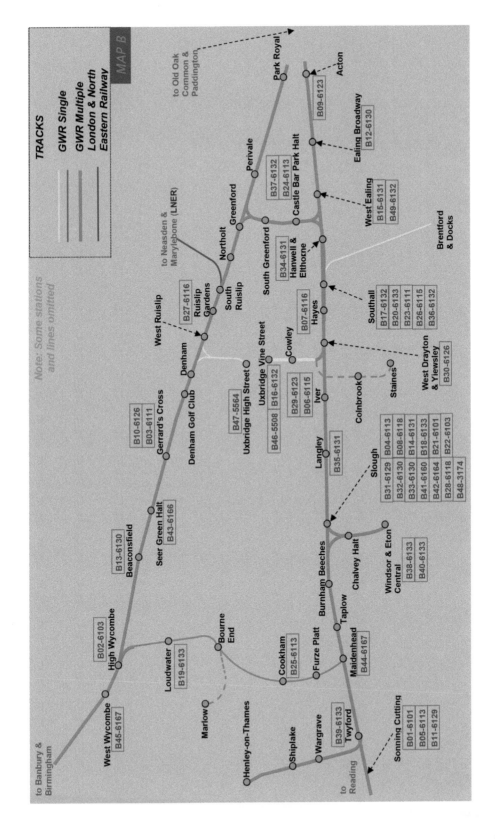

MAP B

TRACKS

GWR Single
GWR Multiple
London & North Eastern Railway

Note: Some stations and lines omitted

to Old Oak Common & Paddington

Park Royal

Acton
B09-6123

Ealing Broadway
B12-6130

Perivale

West Ealing
B15-6131
B49-6132

Greenford

Castle Bar Park Halt
B37-6132
B24-6113

Northolt

South Greenford

Brentford & Docks

to Neasden & Marylebone (LNER)

South Ruislip

Hanwell & Elthorne
B34-6131

Southall
B17-6132
B20-6133
B23-6111
B26-6115
B36-6132

Ruislip Gardens
B27-6116

West Ruislip

Hayes
B07-6116

West Drayton & Yiewsley
B30-6126

Denham

Cowley

Denham Golf Club

Gerrard's Cross
B10-6126
B03-6111

Uxbridge Vine Street

Iver
B29-6123
B06-6115

Uxbridge High Street
B47-5564

B16-6132
B46-5508

Colnbrook

Staines

Langley
B35-6131

Slough
B31-6129 B04-6113
B32-6130 B08-6118
B33-6130 B14-6131
B41-6160 B18-6133
B42-6164 B21-6101
B28-6118 B22-6103
B48-3174

Beaconsfield
B13-6130

Seer Green Halt
B43-6166

Burnham Beeches

Chalvey Halt

Windsor & Eton Central
B38-6133
B40-6133

High Wycombe
B02-6103

Loudwater
B19-6133

Bourne End

Taplow

Cookham
B25-6113

Furze Platt

Maidenhead
B44-6167

to Banbury & Birmingham

West Wycombe
B45-6167

Marlow

Henley-on-Thames

Shiplake

Wargrave

Twyford
B39-6133

to Reading

Sonning Cutting
B01-6101
B05-6113
B11-6129

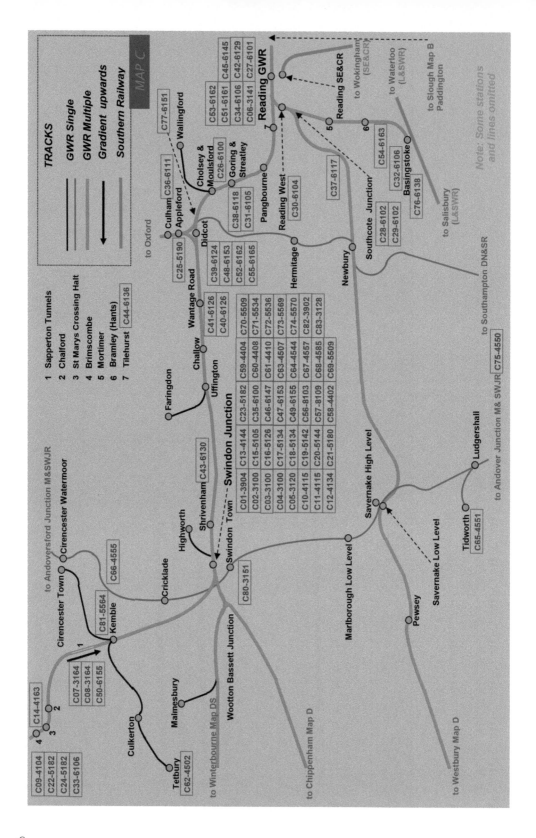

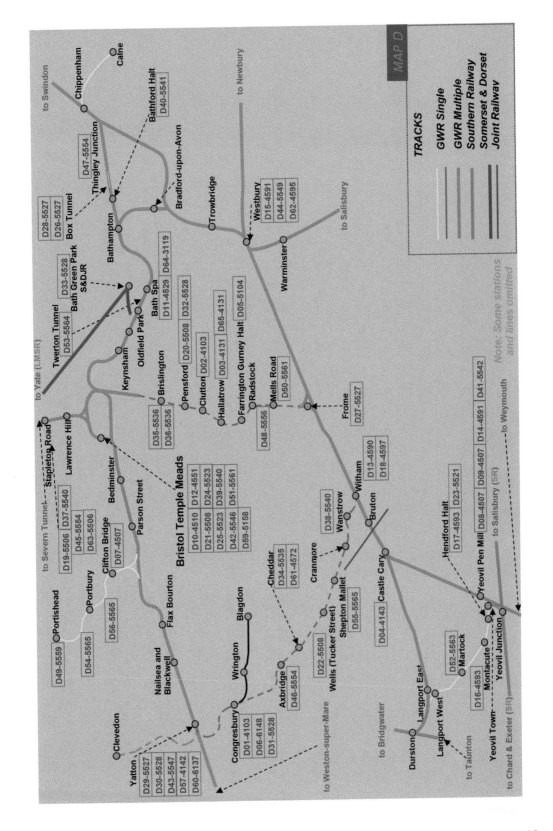

TRACKS

GWR Single
GWR Multiple
Southern Railway
Somerset & Dorset
Joint Railway

Note: Some stations
and lines omitted

to Swindon
Chippenham
Caine
Bathford Halt
D40-5541
to Newbury
D47-5554
Thingley Junction
Box Tunnel
D28-5527
D26-5527
Bradford-upon-Avon
Bathampton
Trowbridge
Westbury
D15-4591
D44-5549
D62-4595
to Salisbury
Twerton Tunnel
D53-5564
Bath Green Park
S&DJR
D33-5528
Bath Spa
D11-4529 D32-5528 D64-3119
Oldfield Park
Warminster
to Yate (LMSR)
Keynsham
Brislington
D35-5536
D36-5536
Pensford D20-5508
Clutton D02-4103
Hallatrow D03-4131 D65-4131
Farrington Gurney Halt D05-5104
Radstock
Mells Road
D50-5561
D48-5556
Frome
D27-5527
to Severn Tunnel
Stapleton Road
Lawrence Hill
Bedminster
Parson Street
Bristol Temple Meads
D10-4510 D12-4551
D21-5508 D24-5523
D25-5523 D39-5540
D42-5546 D51-5561
D59-5158
Witham
D13-4590
D18-4597
to Weston-super-Mare
D49-5559 Portishead
Portbury
Clifton Bridge
D45-5554 D63-5506
D19-5506 D37-5540
D07-4507
Flax Bourton
D56-5565
Nailsea and
Blackwell
D54-5565
Wanstrow
D38-5540
Bruton
Cranmore
Cheddar
D34-5535
D61-4572
Shepton Mallet
D55-5565
Castle Cary
D04-4143
Hendford Halt
D17-4593 D23-5521
to Salisbury (SR)
Yeovil Pen Mill
D08-4507 D09-4507 D14-4591 D41-5542
to Weymouth
Clevedon
Yatton
D29-5527
D30-5528
D43-5547
D57-4142
D60-6137
Congresbury
D01-4103
D06-6148
D31-5528
Wrington
Blagdon
Axbridge
D46-5554
Wells (Tucker Street)
D22-5508
to Bridgwater
Durston
Langport East
Langport West
D16-4593
to Taunton
Martock
D52-5563
Montacute
Yeovil Town
Yeovil Junction
to Chard & Exeter (SR)

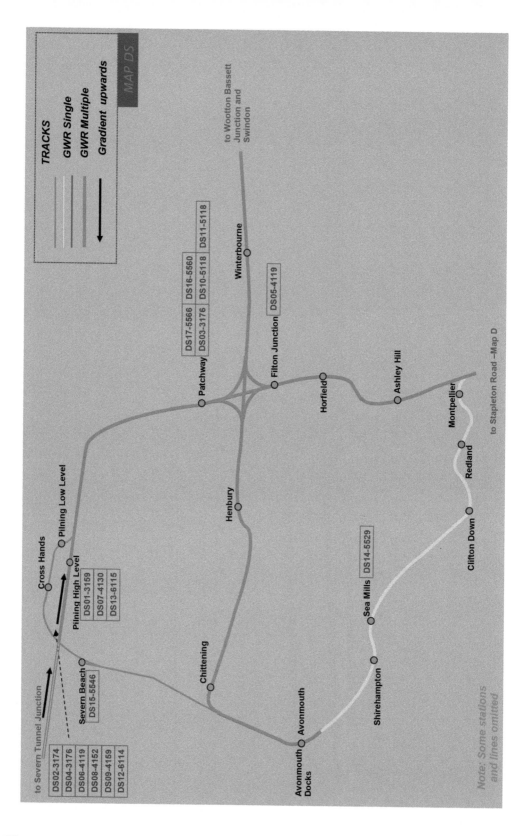

MAP DS

TRACKS

GWR Single
GWR Multiple
Gradient upwards

to Wootton Bassett
Junction and
Swindon

Winterbourne

DS17-5566 DS16-5560
DS03-3176 DS10-5118 DS11-5118

Filton Junction DS05-4119

Patchway

Horfield

Ashley Hill

Montpelier

Redland

to Stapleton Road – Map D

Cross Hands

Pilning Low Level

Pilning High Level

DS01-3159
DS07-4130
DS13-6115

Henbury

Clifton Down

to Severn Tunnel Junction

DS02-3174
DS04-3176
DS06-4119
DS08-4152
DS09-4159
DS12-6114

Severn Beach

DS15-5546

Chittening

Avonmouth

Sea Mills DS14-5529

Shirehampton

Avonmouth
Docks

Note: Some stations
and lines omitted

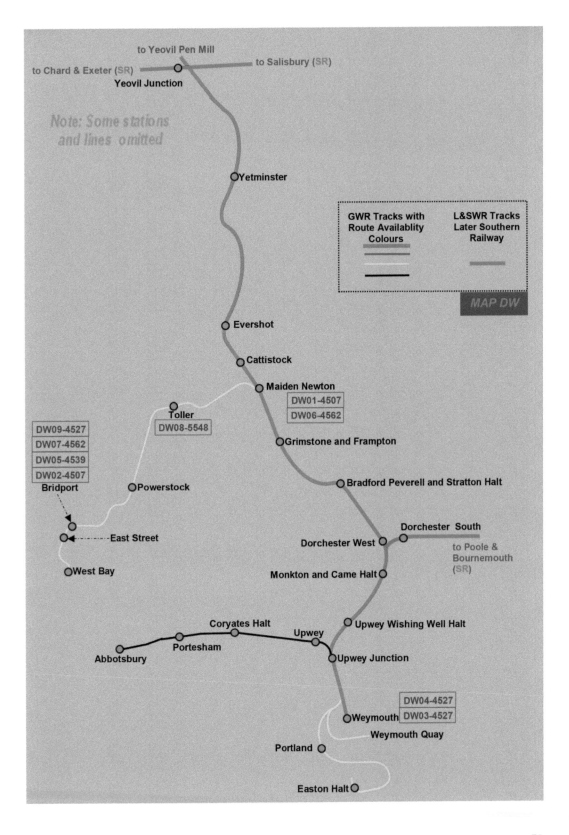

to Yeovil Pen Mill

to Chard & Exeter (SR) — to Salisbury (SR)

Yeovil Junction

Note: Some stations
and lines omitted

Yetminster

GWR Tracks with Route Availablity Colours **L&SWR Tracks Later Southern Railway**

MAP DW

Evershot

Cattistock

Maiden Newton

DW01-4507
DW06-4562

Toller

DW08-5548

DW09-4527
DW07-4562
DW05-4539
DW02-4507

Bridport

Powerstock

Grimstone and Frampton

Bradford Peverell and Stratton Halt

East Street

Dorchester South

West Bay

Dorchester West

to Poole & Bournemouth (SR)

Monkton and Came Halt

Upwey Wishing Well Halt

Coryates Halt

Upwey

Portesham

Abbotsbury

Upwey Junction

DW04-4527
DW03-4527

Weymouth

Weymouth Quay

Portland

Easton Halt

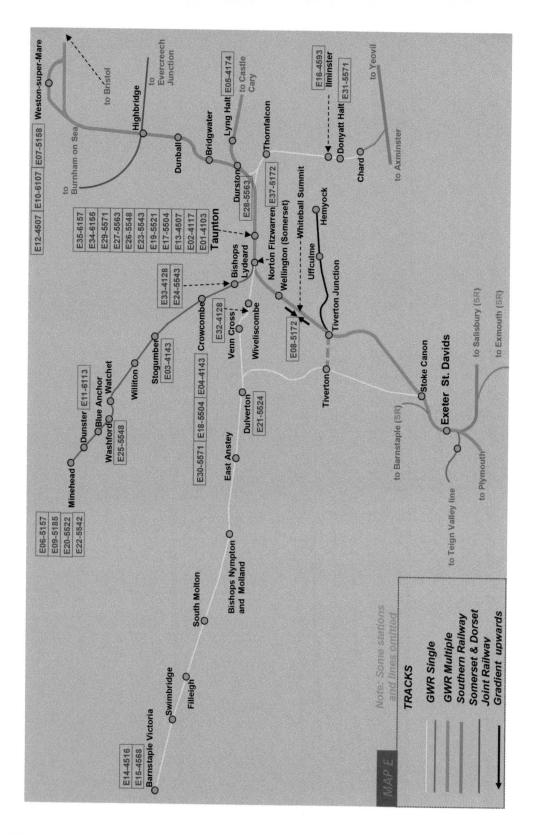

MAP E

TRACKS

GWR Single

GWR Multiple

Southern Railway

Somerset & Dorset Joint Railway

Gradient upwards

Note: Some stations and lines omitted

E06-5157
E09-5185
E20-5522
E22-5542

E14-4516
E15-4568

E11-6113

E25-5548

E03-4143

E30-5571 E18-5504 E04-4143

E32-4128

E21-5524

E33-4128
E24-5543

E35-6157
E34-6155
E29-5571
E27-5563
E26-5548
E23-5643
E19-5521
E17-5504
E13-4507
E02-4117
E01-4103

E28-5563

E37-5172

E08-5172

E05-4174

E16-4593

E31-5571

E12-4507 E10-6107 E07-5158

Weston-super-Mare

to Bristol

to Evercreech Junction

Highbridge

to Burnham on Sea

Dunball

Bridgwater

Lyng Halt

to Castle Cary

Thornfalcon

Ilminster

to Yeovil

Donyatt Halt

Chard

to Axminster

Durston

Taunton

Norton Fitzwarren

Whiteball Summit

Hemyock

Bishops Lydeard

Wellington (Somerset)

Uffculme

Tiverton Junction

Crowcombe

Venn Cross

Wiveliscombe

Stogumber

Williton

Watchet

Blue Anchor

Washford

Dunster

Minehead

Dulverton

Tiverton

Stoke Canon

to Salisbury (SR)

to Exmouth (SR)

Exeter St. Davids

East Anstey

to Barnstaple (SR)

to Plymouth

to Teign Valley line

South Molton

Bishops Nympton and Molland

Swimbridge

Filleigh

Barnstaple Victoria

52

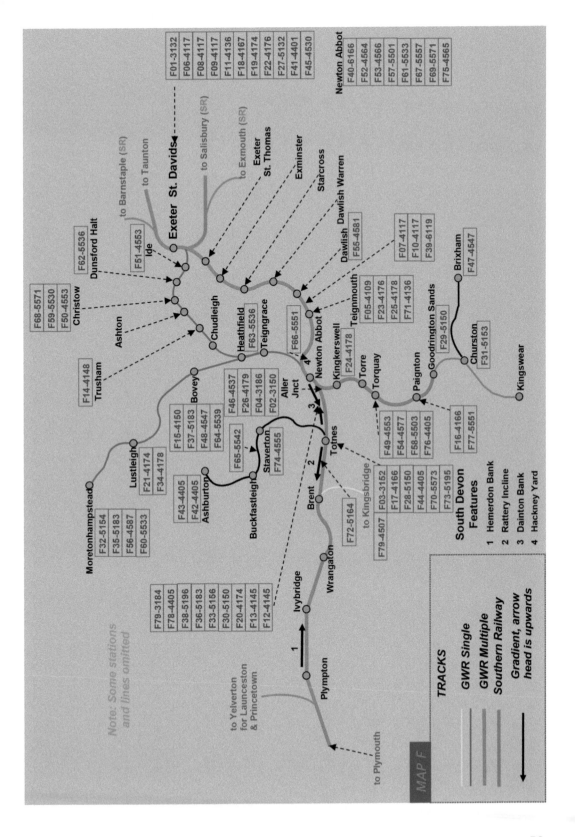

MAP F

53

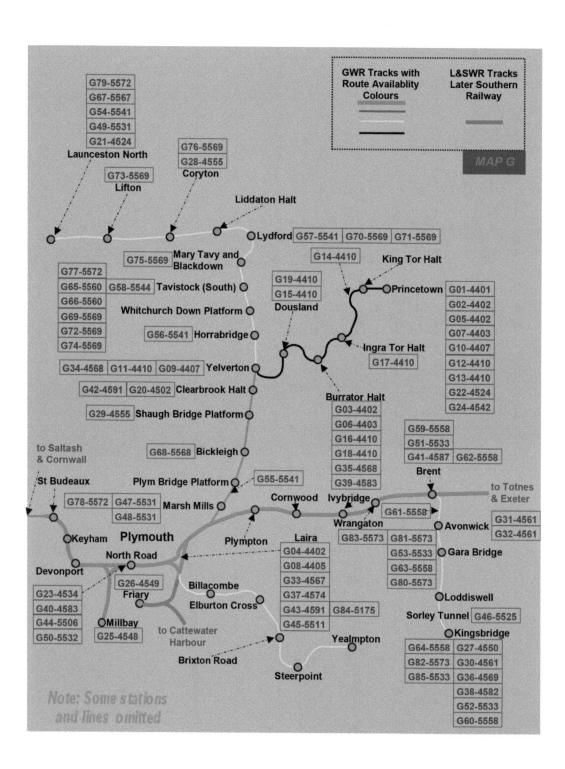

GWR Tracks with Route Availablity Colours

L&SWR Tracks Later Southern Railway

MAP G

G79-5572
G67-5567
G54-5541
G49-5531
G21-4524
Launceston North

G76-5569
G28-4555
Coryton

G73-5569
Lifton

Liddaton Halt

Lydford G57-5541 G70-5569 G71-5569

G75-5569 **Mary Tavy and Blackdown**

G14-4410 **King Tor Halt**

Princetown G01-4401

G77-5572
G65-5560 G58-5544 **Tavistock (South)**
G66-5560
G69-5569
G72-5569
G74-5569

G19-4410
G15-4410
Dousland

G02-4402
G05-4402
G07-4403
G10-4407
G12-4410
G13-4410
G22-4524
G24-4542

Whitchurch Down Platform

G56-5541 **Horrabridge**

Ingra Tor Halt

G17-4410

G34-4568 G11-4410 G09-4407 **Yelverton**

G42-4591 G20-4502 **Clearbrook Halt**

G29-4555 **Shaugh Bridge Platform**

Burrator Halt

G03-4402
G06-4403
G16-4410
G18-4410
G35-4568
G39-4583

G59-5558
G51-5533
G41-4587 G62-5558
Brent

to Saltash & Cornwall

G68-5568 **Bickleigh**

Plym Bridge Platform G55-5541

to Totnes & Exeter

St Budeaux

G78-5572 G47-5531 **Marsh Mills**
G48-5531

Cornwood **Ivybridge**

G61-5558

Avonwick G31-4561
G32-4561

Keyham **Plymouth**

Plympton

Wrangaton

G83-5573 G81-5573

G53-5533 **Gara Bridge**

North Road

Laira

G04-4402
G08-4405
G33-4567
G37-4574
G43-4591 G84-5175
G45-5511

G63-5558
G80-5573

Devonport

G26-4549
Friary

Billacombe

Elburton Cross

Loddiswell

G23-4534
G40-4583
G44-5506
G50-5532

Millbay G25-4548

to Cattewater Harbour

Yealmpton

Sorley Tunnel G46-5525

Kingsbridge

G64-5558 G27-4550
G82-5573 G30-4561
G85-5533 G36-4569
G38-4582
G52-5533
G60-5558

Brixton Road

Steerpoint

Note: Some stations and lines omitted

54

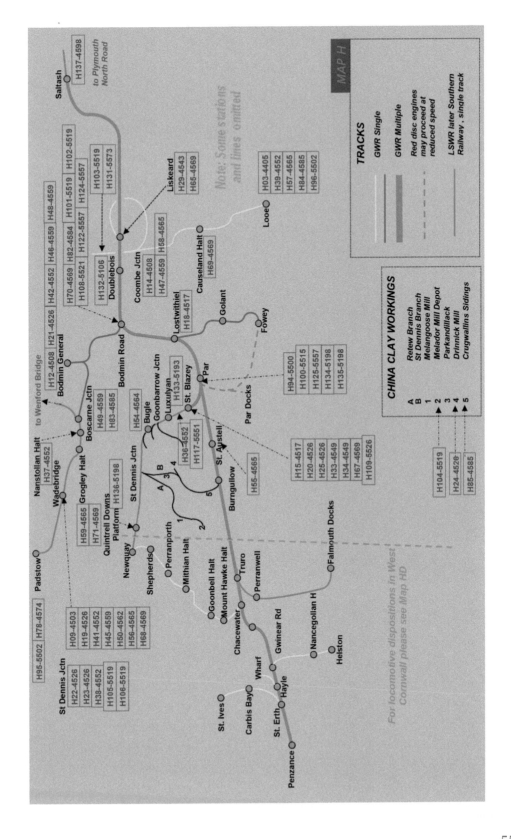

MAP H

Saltash H137-4598

to Plymouth North Road

TRACKS

GWR Single

GWR Multiple

Red disc engines may proceed at reduced speed

LSWR later Southern Railway . single track

Liskeard H29-4543 H65-4569

H102-5519 H101-5519 H48-4559
H103-5519 H124-5557
H131-5573

Doublebois H132-5106

H70-4569 H82-4584 H122-5557
H108-5521 H46-4559

Coombe Jctn H14-4508 H47-4559 H58-4565

H12-4508 H21-4526 H42-4552

Bodmin General

Causeland Halt H69-4569

Looe H03-4405 H39-4552 H57-4565 H84-4585 H96-5502

to Wenford Bridge

Nanstollan Halt H37-4552

Boscarne Jctn

Wadebridge

Bodmin Road

Lostwithiel H18-4517

Golant

Fowey

CHINA CLAY WORKINGS

A Retew Branch
B St Dennis Branch
1 Melangoose Mill
2 Melador Mill Depot
3 Parkandillack
4 Drinnick Mill
5 Crugwallins Sidings

H104-5519
H24-4526
H85-4585

Grogley Halt H59-4565 H71-4569

Quintrell Downs Platform H136-5198

St Dennis Jctn

Bugle H54-4564

Goonbarrow Jctn H49-4559 H83-4585

Luxulyan H133-5193

St. Blazey H36-4552 H117-5551

Par

Par Docks

H94-5500 H100-5515 H125-5557 H134-5198 H135-5198

Newquay

Shepherds

Perranporth

Mithian Halt

St. Austell

Burngullow

H15-4517 H20-4526 H25-4526 H33-4549 H34-4549 H67-4569 H109-5526

H56-4565

Goonbell Halt

Mount Hawke Halt

Truro

Perranwell

Falmouth Docks

Chacewater

Gwinear Rd

Nancegollan H

Helston

St Dennis Jctn
H22-4526 H23-4526 H38-4552 H105-5519 H106-5519

Padstow

H95-5502 H78-4574

H09-4503 H19-4526 H41-4552 H45-4559 H50-4562 H56-4565 H68-4569

St. Ives

Carbis Bay

Hayle

Wharf

St. Erth

Penzance

Note: Some stations and lines omitted

For locomotive dispositions in West Cornwall please see Map HD

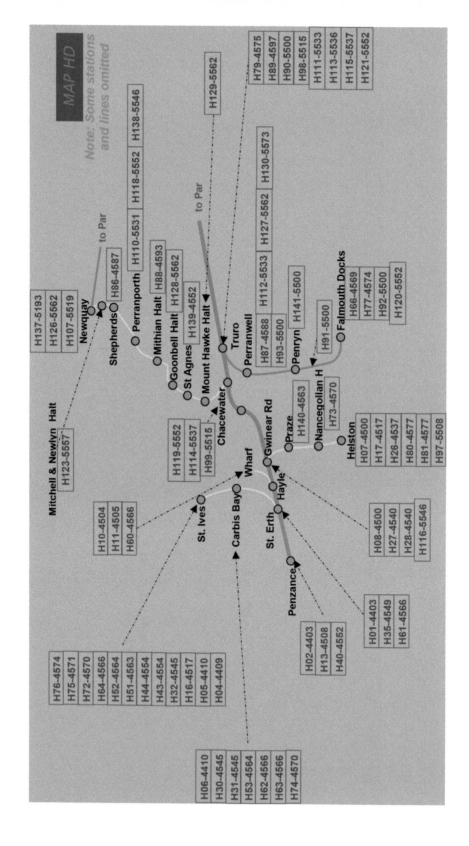

MAP HD

Note: Some stations and lines omitted

56

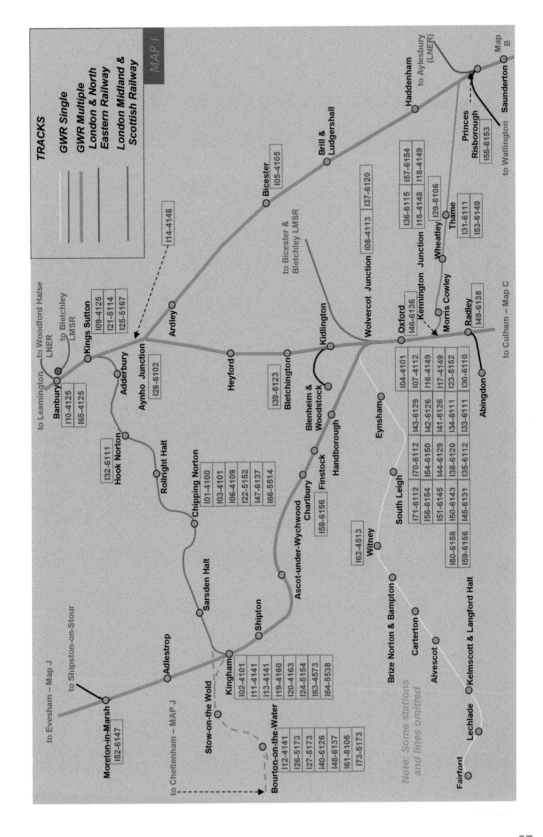

MAP 1

TRACKS

GWR Single

GWR Multiple

London & North
Eastern Railway

London Midland &
Scottish Railway

to Leamington — to Woodford Halse
LNER

to Bletchley
LMSR

Banbury
110-4125
165-4125

Kings Sutton
109-4125
121-5114
125-5167

114-4148

to Bicester &
Bletchley LMSR

Ardley

Bicester
105-4105

Brill &
Ludgershall

Haddenham

to Aylesbury
(LNER)

Saunderton

Map
B

Princes
Risborough
155-6153

to Watlington

Adderbury
128-6102

Aynho Junction

Heyford

Bletchington
139-6123

Kidlington

Wolvercot Junction
108-4113 137-6120

Oxford
146-6136

Kennington
Junction

Morris Cowley

Wheatley
115-4148 118-4149
129-6106

Thame
131-6111
153-6149

136-6115 157-6154

Radley
149-6138

to Culham – Map C

Hook Norton
132-6111

Rollright Halt

Chipping Norton
101-4100
103-4101
106-4109
122-5152
147-6137
166-5514

Blenheim &
Woodstock

Handborough

Finstock

Charlbury

Ascot-under-Wychwood
158-6156

Eynsham

Oxford (stations)
104-4101 107-4112 116-4149 117-4149 123-5152 130-6110
143-6129 142-6126 141-6126 134-6111 133-6111
171-6112 170-6112 154-6150 144-6129 138-6120 135-6112
156-6154 151-6145 150-6143 145-6131
160-6158 159-6156

South Leigh

Witney
162-4513

to Evesham – Map J

to Shipston-on-Stour

Moreton-in-Marsh
152-6147

Adlestrop

Sarsden Halt

Shipton

to Cheltenham – MAP J

Stow-on-the-Wold

Kingham
102-4101 111-4141 113-4141 119-4160 120-4163 124-5154 163-4573 164-5538

Bourton-on-the-Water
112-4141 126-5173 127-5173 140-6126 148-6137 161-8106 173-5173

*Note: Some stations
and lines omitted*

Brize Norton & Bampton

Carterton

Alvescot

Fairford

Lechlade

Kelmscott & Langford Halt

57

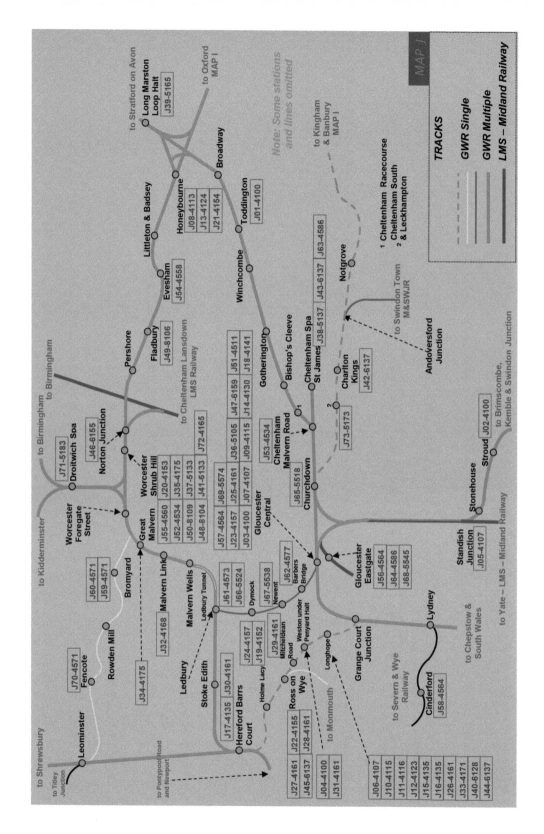

MAP J

to Tidley Junction
to Shrewsbury
Leominster
to Pontypool Road and Newport
J70-4571
Fencote
Rowden Mill
Bromyard
J60-4571
J59-4571
to Kidderminster
Worcester Foregate Street
Great Malvern
J55-4560
J52-4534
J50-8109
J48-8104
to Birmingham
to Birmingham
J71-5183
Droitwich Spa
J46-6155
Norton Junction
Worcester Shrub Hill
J20-4153
J35-4175
J37-5133
J41-6133
J72-4165
Pershore
Fladbury
J49-8106
Evesham
J54-4558
Littleton & Badsey
Honeybourne
J08-4113
J13-4124
J21-4154
to Stratford on Avon
Long Marston Loop Halt
J39-5165
to Oxford
MAP I
Broadway
Toddington
J01-4100
Winchcombe

Note: Some stations and lines omitted

J32-4168
Malvern Link
Malvern Wells
Ledbury Tunnel
Ledbury
J34-4175
Stoke Edith
J61-4573
J66-5524
Dymock
J67-5538
Newent
Weston under Penyard Halt
Mitcheldean Road
J24-4157
J19-4152
Ross on Wye
Holme Lacy
J30-4161
Hereford Barrs Court
J17-4135
J27-4161
J45-6137
J04-4100
J31-4161
to Monmouth
Longhope
J62-4577
Barbers Bridge
J29-4161
Grange Court Junction
to Severn & Wye Railway
Cinderford
J58-4564
Lydney
to Chepstow & South Wales

Gloucester Central
J57-4564
J23-4157
J03-4100
J36-5105
J25-4161
J07-4107
J69-5574
J47-6159
J14-4130
J51-4511
J18-4141
Gotherington
Bishop's Cleeve
Cheltenham Spa St James
J38-5137
J43-6137
J63-4586
Notgrove
to Kingham & Banbury
MAP I

Cheltenham Malvern Road
J53-4534
J65-5518
Churchdown
Gloucester Eastgate
J56-4564
J64-4586
J68-5545
Standish Junction
J05-4107

Charlton Kings
J42-6137
J73-5173
to Swindon Town M&SWJR
Andoversford Junction

Stonehouse
Stroud
J02-4100
to Brimscombe, Kemble & Swindon Junction
to Yate – LMS – Midland Railway

to Cheltenham Lansdown LMS Railway

J06-4107
J10-4115
J11-4116
J12-4123
J15-4135
J16-4135
J26-4161
J33-4171
J40-6128
J44-6137

J22-4155
J28-4161

1 Cheltenham Racecourse
Cheltenham South
2 & Leckhampton

TRACKS

GWR Single
GWR Multiple
LMS – Midland Railway

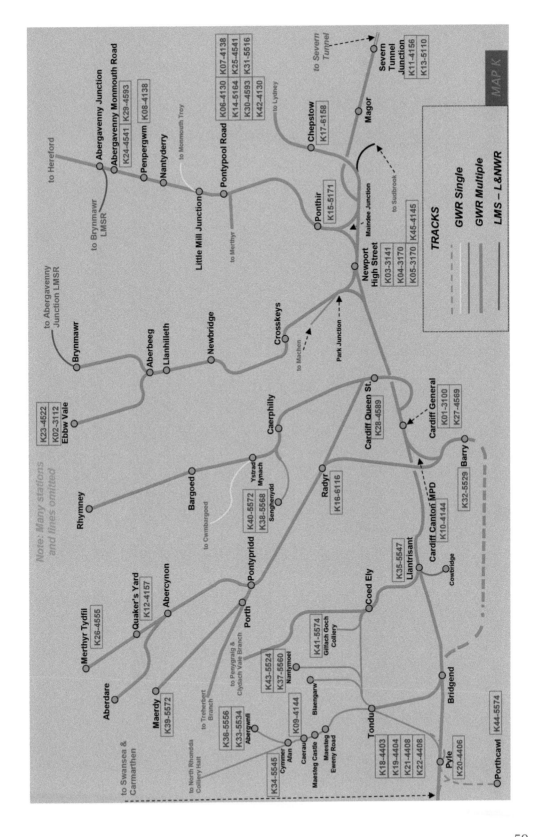

MAP K

Severn Tunnel Junction
K11-4156
K13-5110

to Severn Tunnel

Magor

Chepstow
K17-6158

to Lydney

to Sudbrook

Maindee Junction

Ponthir
K15-5171

to Monmouth Troy

Pontypool Road
K06-4130 K07-4138
K14-5164 K25-4541
K30-4593 K31-5516
K42-4130

Little Mill Junction

to Merthyr

Nantyderry

Penpergwm K08-4138

Abergavenny Monmouth Road
K24-4541 K29-4593

Abergavenny Junction

to Hereford

to Brynmawr LMSR

Newport High Street
K03-3141
K04-3170
K05-3170 K45-4145

Park Junction

to Machen

Crosskeys

Newbridge

Llanhilleth

Aberbeeg

Brynmawr

to Abergavenny Junction LMSR

Ebbw Vale
K23-4522
K02-3112

Rhymney

Bargoed

Ystrad Mynach
K40-5572
K38-5568
Senghenydd

to Cwmbargoed

Caerphilly

Cardiff Queen St.
K28-4589

Cardiff General
K01-3100
K27-4569

Cardiff Canton MPD
K10-4144

Barry
K32-5529

Radyr
K16-6116

Coed Ely

Llantrisant
K35-5547

Cowbridge

Pontypridd
K40-5572 (see above)

Porth

Abercynon

Quaker's Yard
K12-4157

Merthyr Tydfil
K26-4555

Aberdare

Maerdy
K39-5572

to Treherbert Branch

to North Rhondda Colliery Halt

to Swansea & Carmarthen

to Penygraig & Clydach Vale Branch

Nantymoel
K43-5524
K37-5560

Gilfach Goch Colliery
K41-5574

Blaengarw

Abergwnfi
K36-5556
K33-5534

Cymmer Afan
K34-5545

Caerau

Maesteg Castle
Maesteg
Ewenny Road
K09-4144

Tondu
K18-4403
K19-4404
K21-4408
K22-4408

Bridgend

Pyle
K20-4406

Porthcawl
K44-5574

Note: Many stations and lines omitted

TRACKS

GWR Single

GWR Multiple

LMS – L&NWR

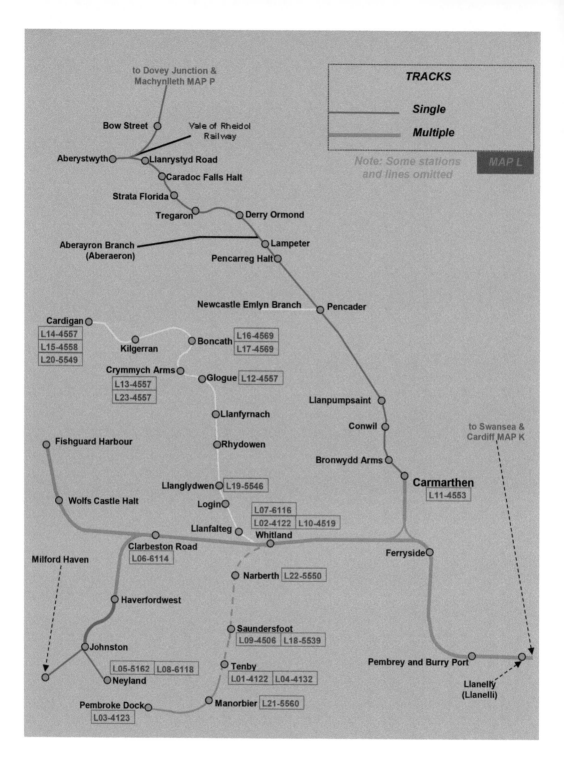

to Dovey Junction &
Machynlleth MAP P

Bow Street

Vale of Rheidol
Railway

Aberystwyth

Llanrystyd Road

Caradoc Falls Halt

Strata Florida

Tregaron

Derry Ormond

Aberayron Branch
(Aberaeron)

Lampeter

Pencarreg Halt

Newcastle Emlyn Branch

Pencader

Cardigan

L14-4557
L15-4558
L20-5549

Kilgerran

Boncath

L16-4569
L17-4569

Crymmych Arms

L13-4557
L23-4557

Glogue L12-4557

Llanpumpsaint

Llanfyrnach

Conwil

Fishguard Harbour

Rhydowen

Bronwydd Arms

to Swansea &
Cardiff MAP K

Llanglydwen L19-5546

Carmarthen

L11-4553

Wolfs Castle Halt

Login

L07-6116

L02-4122 L10-4519

Llanfalteg

Clarbeston Road

L06-6114

Whitland

Ferryside

Milford Haven

Narberth L22-5550

Haverfordwest

Saundersfoot

L09-4506 L18-5539

Johnston

L05-5162 L08-6118

Neyland

Tenby

L01-4122 L04-4132

Pembrey and Burry Port

Llanelly
(Llanelli)

Pembroke Dock

L03-4123

Manorbier L21-5560

TRACKS

Single

Multiple

Note: Some stations
and lines omitted

MAP L

60

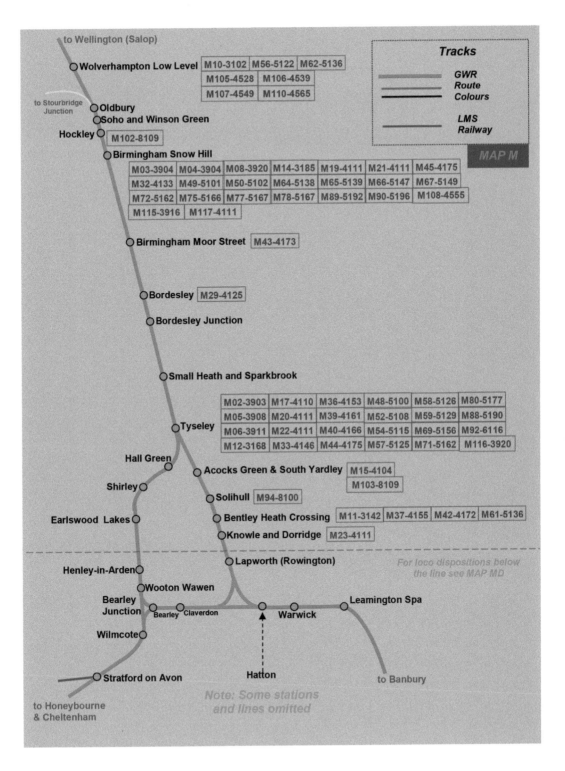

to Wellington (Salop)

Wolverhampton Low Level

M10-3102	M56-5122	M62-5136
M105-4528	M106-4539	
M107-4549	M110-4565	

to Stourbridge Junction

Oldbury

Soho and Winson Green

Hockley

M102-8109

Birmingham Snow Hill

M03-3904	M04-3904	M08-3920	M14-3185	M19-4111	M21-4111	M45-4175
M32-4133	M49-5101	M50-5102	M64-5138	M65-5139	M66-5147	M67-5149
M72-5162	M75-5166	M77-5167	M78-5167	M89-5192	M90-5196	M108-4555
M115-3916	M117-4111					

Birmingham Moor Street

M43-4173

Bordesley

M29-4125

Bordesley Junction

Small Heath and Sparkbrook

M02-3903	M17-4110	M36-4153	M48-5100	M58-5126	M80-5177
M05-3908	M20-4111	M39-4161	M52-5108	M59-5129	M88-5190
M06-3911	M22-4111	M40-4166	M54-5115	M69-5156	M92-6116
M12-3168	M33-4146	M44-4175	M57-5125	M71-5162	M116-3920

Tyseley

Hall Green

Acocks Green & South Yardley

M15-4104
M103-8109

Shirley

Solihull

M94-8100

Earlswood Lakes

Bentley Heath Crossing

M11-3142	M37-4155	M42-4172	M61-5136

Knowle and Dorridge

M23-4111

For loco dispositions below the line see MAP MD

Henley-in-Arden

Lapworth (Rowington)

Wooton Wawen

Bearley Junction Bearley Claverdon

Leamington Spa

Warwick

Wilmcote

Stratford on Avon

Hatton

to Banbury

to Honeybourne & Cheltenham

Note: Some stations and lines omitted

Tracks

———	GWR Route Colours
———	LMS Railway

MAP M

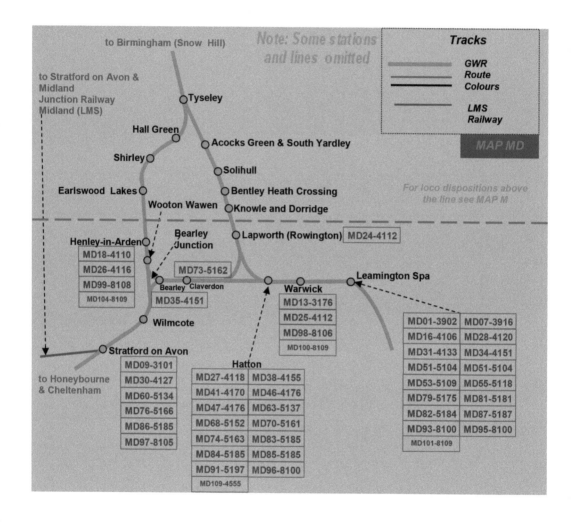

to Birmingham (Snow Hill)

Note: Some stations and lines omitted

Tracks

GWR
Route
Colours

LMS
Railway

MAP MD

to Stratford on Avon &
Midland
Junction Railway
Midland (LMS)

Tyseley

Hall Green

Acocks Green & South Yardley

Shirley

Solihull

Earlswood Lakes

Bentley Heath Crossing

Wooton Wawen

Knowle and Dorridge

For loco dispositions above
the line see MAP M

Henley-in-Arden

Bearley
Junction

Lapworth (Rowington) | MD24-4112 |

| MD18-4110 |
| MD26-4116 |
| MD99-8108 |
| MD104-8109 |

| MD73-5162 |

Bearley Claverdon

Leamington Spa

| MD35-4151 |

Warwick

Wilmcote

| MD13-3176 |
| MD25-4112 |
| MD98-8106 |
| MD100-8109 |

MD01-3902	MD07-3916
MD16-4106	MD28-4120
MD31-4133	MD34-4151
MD51-5104	MD51-5104
MD53-5109	MD55-5118
MD79-5175	MD81-5181
MD82-5184	MD87-5187
MD93-8100	MD95-8100
MD101-8109	

Stratford on Avon

Hatton

| MD09-3101 |
| MD30-4127 |
| MD60-5134 |
| MD76-5166 |
| MD86-5185 |
| MD97-8105 |

to Honeybourne
& Cheltenham

MD27-4118	MD38-4155
MD41-4170	MD46-4176
MD47-4176	MD63-5137
MD68-5152	MD70-5161
MD74-5163	MD83-5185
MD84-5185	MD85-5185
MD91-5197	MD96-8100
MD109-4555	

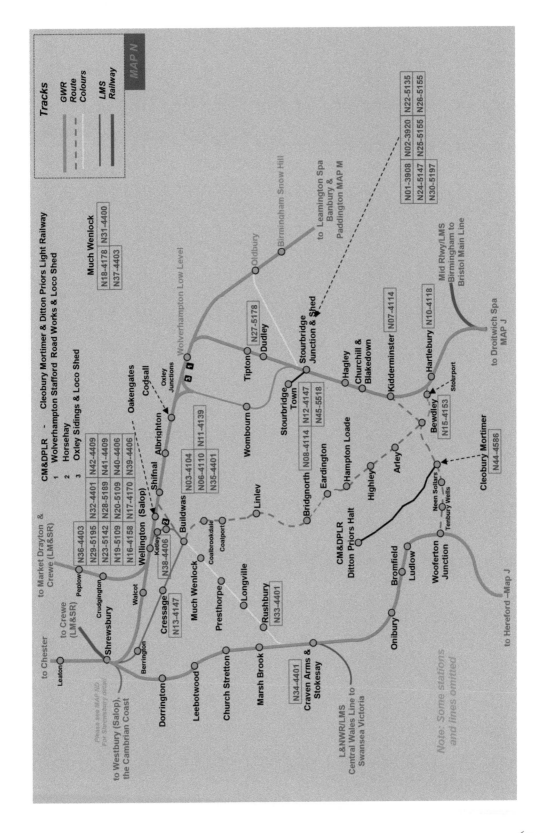

Tracks

GWR
Route
Colours

LMS
Railway

MAP N

CM&DPLR - Cleobury Mortimer & Ditton Priors Light Railway
1 Wolverhampton Stafford Road Works & Loco Shed
2 Horsehay
3 Oxley Sidings & Loco Shed

Much Wenlock

| N18-4178 | N31-4400 |
| N37-4403 | |

N01-3908	N02-3920	N22-5135
N24-5147	N25-5155	N26-5155
N30-5197		

to Leamington Spa
Banbury &
Paddington MAP M

Mid Rlwy/LMS
Birmingham to
Bristol Main Line

Birmingham Snow Hill

Oldbury

to Droitwich Spa
MAP J

Wolverhampton Low Level

Stourbridge
Junction & Shed

Kidderminster N07-4114

Hartlebury N10-4118

Tipton N27-5178
Dudley

Tipton

Hagley
Churchill &
Blakedown

Bewdley
N15-4153

Stotport

Oxley
Junctions

Codsall

Oakengates

Shifnal Albrighton

Stourbridge
Town N12-4147
N45-5518

N08-4114

Wombourn

Cleobury Mortimer
N44-4586

Bridgnorth

N03-4104	N11-4139
N06-4110	
N35-4401	

Eardington

Hampton Loade

Highley

Arley

Linley

Buildwas

Wellington (Salop)

N36-4403	N29-5195	N32-4401	N42-4409	
	N23-5142	N28-5189	N41-4409	
	N16-4158	N19-5109	N20-5109	N40-4406
		N17-4170	N39-4406	

Peplow

Crudgington

Walcot

Ketley N38-4406

Coalbrookdale

Coalport

CM&DPLR
Ditton Priors Halt

Neen Sollars
Tenbury Wells

Wooferton
Junction

Bromfield

Ludlow

to Chester

to Crewe
(LM&SR)

to Market Drayton &
Crewe (LM&SR)

Shrewsbury

Leaton

Please see MAP ND
For Shrewsbury detail

to Westbury (Salop),
the Cambrian Coast

Berrington

Dorrington

Cressage
N13-4147

Much Wenlock

Presthorpe

Longville

Rushbury
N33-4401

Leebotwood

Church Stretton

Marsh Brook

N34-4401

Craven Arms &
Stokesay

Onibury

to Hereford –Map J

L&NWR/LMS
Central Wales Line to
Swansea Victoria

Note: *Some stations
and lines omitted*

63

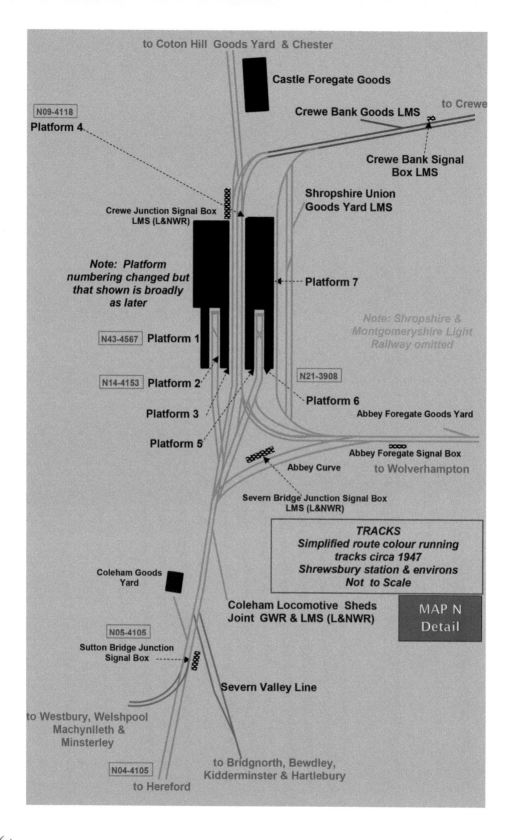

to Coton Hill Goods Yard & Chester

Castle Foregate Goods

Crewe Bank Goods LMS

to Crewe

N09-4118
Platform 4

Crewe Bank Signal
Box LMS

Shropshire Union
Goods Yard LMS

Crewe Junction Signal Box
LMS (L&NWR)

*Note: Platform
numbering changed but
that shown is broadly
as later*

Platform 7

Note: Shropshire &
Montgomeryshire Light
Railway omitted

N43-4567 Platform 1

N14-4153 Platform 2

N21-3908

Platform 3

Platform 6

Platform 5

Abbey Foregate Goods Yard

Abbey Foregate Signal Box

Abbey Curve

to Wolverhampton

Severn Bridge Junction Signal Box
LMS (L&NWR)

*TRACKS
Simplified route colour running
tracks circa 1947
Shrewsbury station & environs
Not to Scale*

Coleham Goods
Yard

Coleham Locomotive Sheds
Joint GWR & LMS (L&NWR)

MAP N
Detail

N05-4105
Sutton Bridge Junction
Signal Box

Severn Valley Line

to Westbury, Welshpool
Machynlleth &
Minsterley

N04-4105
to Hereford

to Bridgnorth, Bewdley,
Kidderminster & Hartlebury

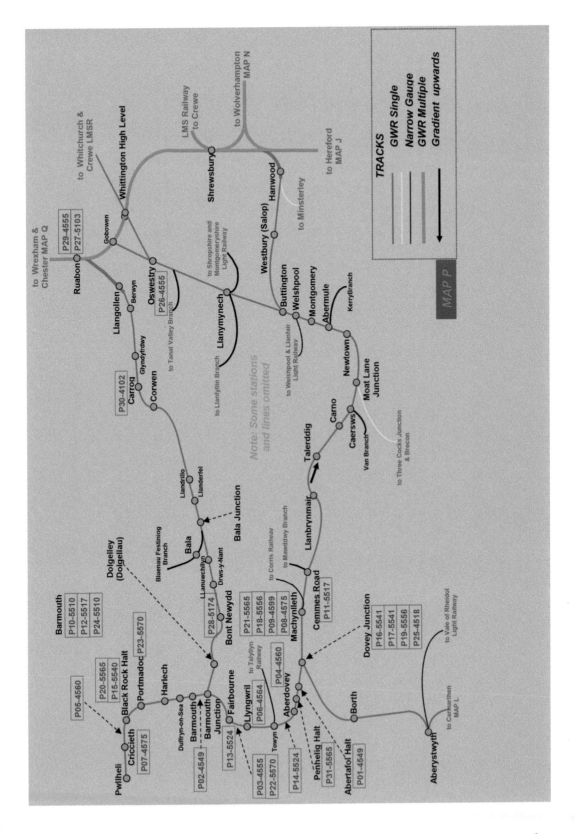

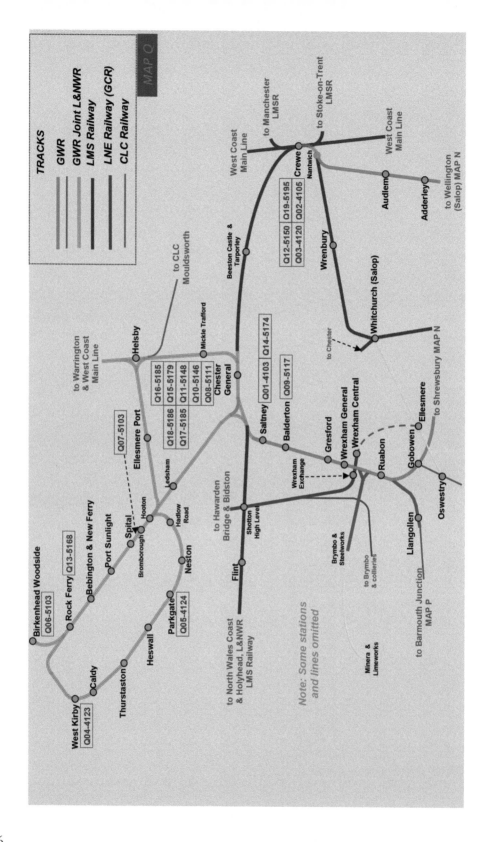

MAP Q

TRACKS

GWR	
GWR Joint L&NWR	
LMS Railway	
LNE Railway (GCR)	
CLC Railway	

to Manchester LMSR

to Stoke-on-Trent LMSR

West Coast Main Line

Crewe

Nantwich

West Coast Main Line

Audlem

Adderley

to Wellington (Salop) MAP N

Q12-5150 Q19-5195
Q03-4120 Q02-4105

Wrenbury

Beeston Castle & Tarporley

Whitchurch (Salop)

to CLC Mouldsworth

Helsby

Mickle Trafford

to Warrington & West Coast Main Line

to Chester

Q16-5185 Q15-5179 Q11-5148 Q10-5146 Q08-5111
Q18-5186 Q17-5185

Chester General

Saltney Q01-4103 Q14-5174

Balderton Q09-5117

Ellesmere Port Q07-5103

Ledsham

Spital

Hooton

Bromborough

Hadlow Road

Neston

Port Sunlight

Bebington & New Ferry

Rock Ferry Q06-5103

Birkenhead Woodside

Q13-5168

Caldy

West Kirby Q04-4123

Thurstaston

Heswall

Parkgate Q05-4124

Gresford

Wrexham General

Wrexham Central

Wrexham Exchange

Ruabon

Gobowen

Ellesmere

to Shrewsbury MAP N

Oswestry

Llangollen

to Barmouth Junction MAP P

Minera & Limeworks

to Brymbo & collieries

Brymbo & Steelworks

Shotton High Level

Flint

to Hawarden Bridge & Bidston

to North Wales Coast & Holyhead, L&NWR LMS Railway

Note: Some stations and lines omitted

5

The Prairie Gallery

A selection of photographs of the locomotives in GWR and BR service, and in preservation.

3163 awaiting banking duties at Brimscombe shed for Sapperton inclines. Chalked legend 'PREPARED KEEP OFF 16/8/56'. Crew in attendance. This engine would be withdrawn on 24 June 1957 after fifty years' service. Track AWS ramp in the foreground. MAP C. (Great Western Trust)

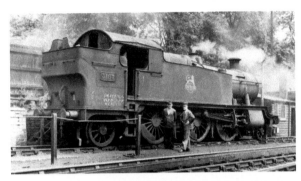

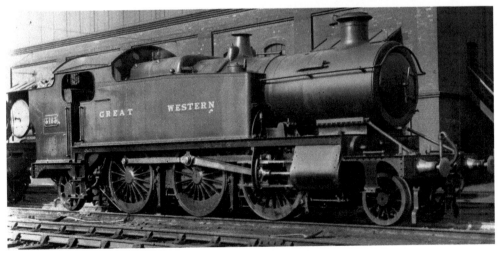

3163 in happier times at Old Oak Common depot in around 1932, about halfway through its working life. The 290,000-gallon water tank above the coal stage was needed to keep the allocation of over 230 locomotives topped up. In severe winters the loco that handled the coaling could be placed inside the plant to avoid the water in the tank freezing. Locomotives were usually prohibited from entering such structures. MAP A. (Great Western Trust)

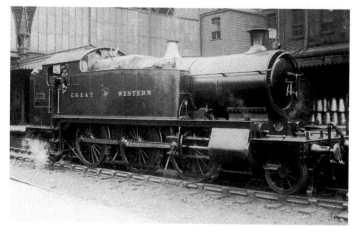

3165 in around 1911 in garter crest livery at platform 1 Paddington out by the milk dock extension, which had been built in 1908. The loco appears to be from a suburban passenger train judging by the B headcode. The loco has a cast-iron chimney, small bunker, outside brake rigging on the first four driving wheels and no top feed with tall safety valve bonnet. MAP A. (Great Western Trust)

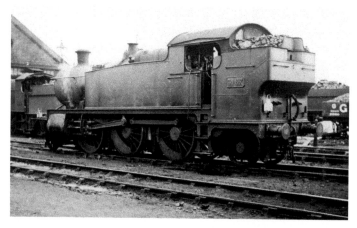

3167 is in fine condition considering it spends a good deal of its time in the Severn Tunnel but is depicted here at Severn Tunnel Junction shed before the addition of the extra two roads. Seen in around 1938 before the changes in 1939. MAP K. (Great Western Trust)

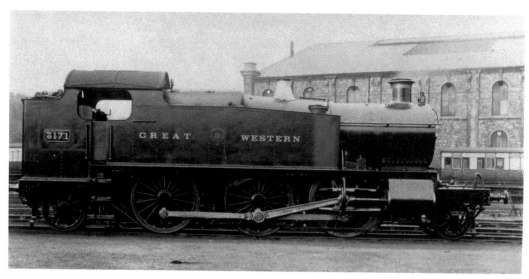

3171 in as-built condition in 1907 outside Exeter St Davids with B headcode for a local passenger train. All the early features are present but the engine has a copper-capped chimney. The two-way water-scoop-fitted engines stopped at 3170. MAP F. (Great Western Trust)

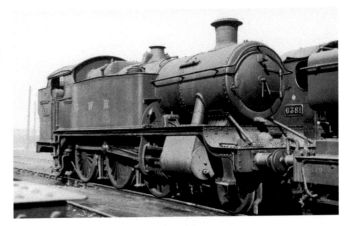

3171 around forty years after the previous figure in around 1947 at Gloucester Horton Road depot. The 2021 class pannier tank whose front end is just visible has 'LYD for Lydney' stencilled on the valance next to the buffer beam. The 63XX Mogul 6381, also a Gloucester engine, is also in 1942 livery with the route colour disc and power class letter above the number plate. MAP J. (Great Western Trust)

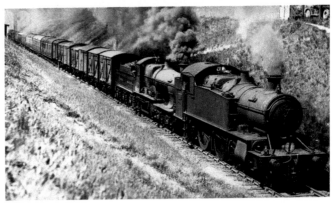

3150 Class 3176 pilots 4-4-0 Bulldog 3392 New Zealand on a lengthy parcels train from South Wales in March 1936. The hut at the top left of the picture is the lamp hut for Patchway Tunnel signal box. Target 1 required the pilot to remain at the head of the train until Patchway, then uncouple and return for another duty. MAP DS04. (Great Western Trust)

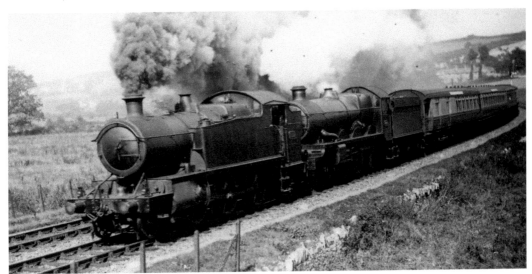

3177 pilots an early series Castle 4-6-0 up Rattery Bank towards Plymouth in the summer of late 1920s. The loco has had the steam heating pipe removed as the train engine would always be supplying this feature if required. The coaching stock is mixture of Churchward types and the home signal back down the bank has been very smartly returned to danger, possibly before the last vehicles have passed the post. MAP G. (Great Western Trust)

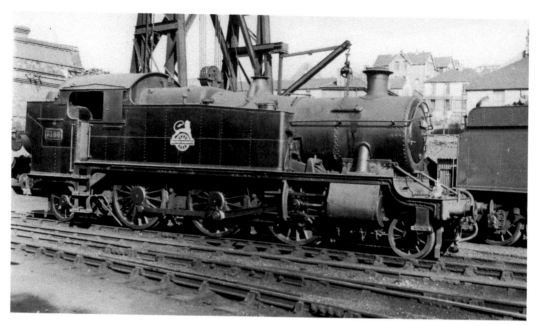

3150 Class 3186 is at its home depot of Plymouth Laira by the hoist and a loco has been separated from its 4,000-gallon tender for a lift. This is around 1955 and the loco would have only about two years left in service before withdrawal. Despite, or perhaps because of, its higher red route availability the engine would just fail to see fifty years' service. MAP G. (Great Western Trust)

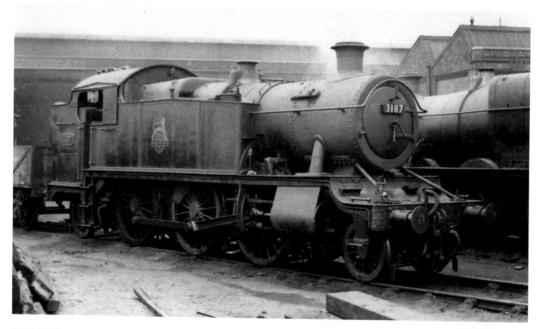

3187 is also a resident of Laira for most of its working life of just under fifty years, succumbing to withdrawal in November 1957. All modern features are present, including the moving of the top lamp iron to the smokebox door from beneath the chimney, a process carried out on numerous GWR classes in the 1930s and on this class from 1933. In GWR days the front coupling would have been secured on the hook under the right-hand buffer. MAP G. (Great Western Trust)

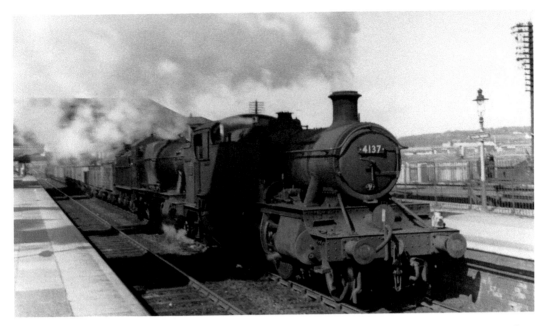

5101 Class 4137 pilots an early series 28XX 2-8-0 freight loco through Severn Tunnel station on their way to the tunnel with around thirty loaded mineral wagons of coal. Target 1 disc means the Prairie will stay with the head of the train until Patchway and be detached there. 4137 was built in November 1939 and stayed at Severn Tunnel Junction for most of its life until withdrawal in October 1964. MAP K. (Great Western Trust)

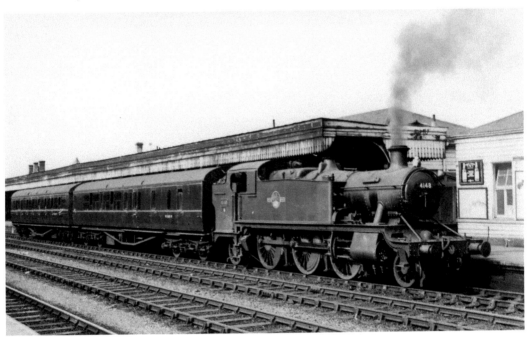

5101 Class 4148 waits at the Down platform at Oxford with a B lamps stopper in around 1959. Built in 1946, this engine would see service over a good deal of the GWR network, ending up at Oxley, Wolverhampton, in 1965. MAP I. (Great Western Trust)

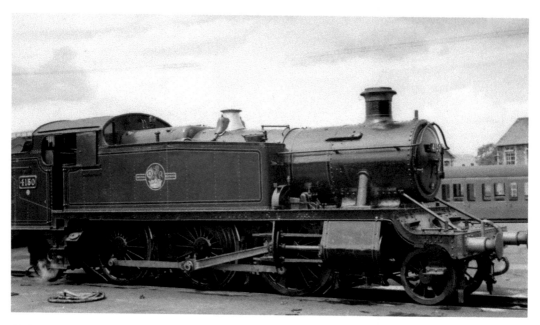

4150 is pristine at Swindon Works in July 1961 in full lined green BR livery and heading for 83A Newton Abbot for a second turn of duty there. This loco would end its days at Severn Tunnel Junction in June 1965. MAP C. (Great Western Trust)

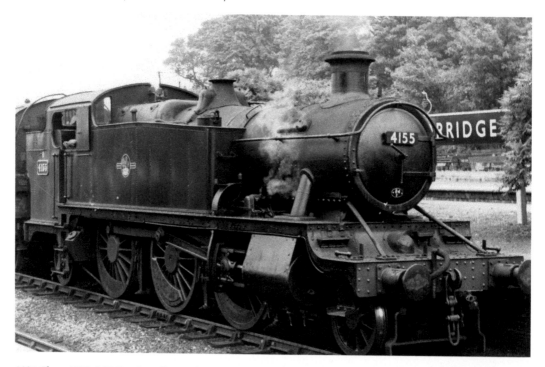

5101 Class 4155, 84E Tyseley allocated, is in fine clean condition at Knowle and Dorridge station on a Snow Hill to Leamington train in around 1961. The first coach appears to be a BR Mark 1 example. 4155 would spend over ten years at Tyseley and be withdrawn from there in September 1965. MAP M. (Great Western Trust)

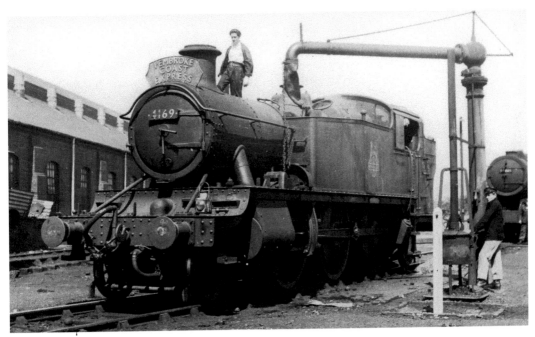

5101 Class 4169 proudly displays the Pembroke Coast Express headboard, the train the loco would have worked from Pembroke Dock to Whitland or Camarthen, whereupon a Castle would take over. The scene is 1959 and the WD 2-8-0 90485 was a Carmarthen engine at the time, placing both at that depot. MAP L. (Great Western Trust)

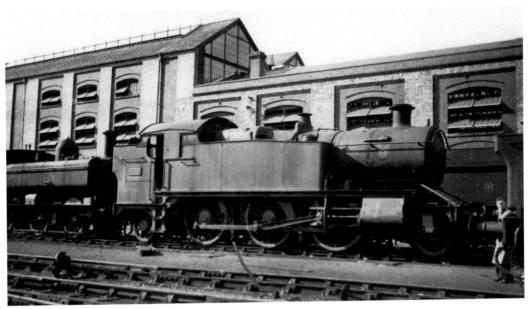

3150 Class 3168 is at Swindon Works in around 1939 and by then this engine had achieved all the updates it was to get except outside steam pipes, which it never carried. It had originally been one of the four that carried two-way water scoop apparatus, but that had been removed after a few years. The engine would see a little over forty-three years' service, and its last shed was Severn Tunnel Junction. MAP C. (Great Western Trust)

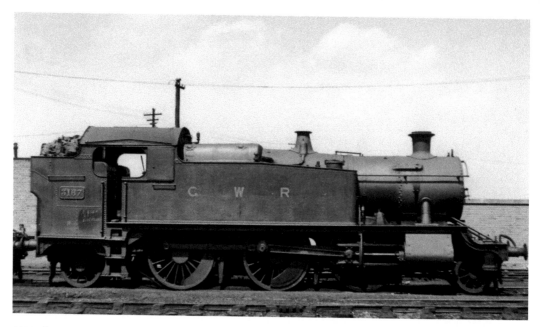

3150 Class 3167 is still in fairly clean condition (see figure 13) despite having just endured the Second World War and most of it in the Severn Tunnel. It acquired outside steam pipes in January 1941 and is depicted in post-1942 livery. The chalked inscription reads 'DANGER NO FOOTPLATE'. MAP K. (Great Western Trust)

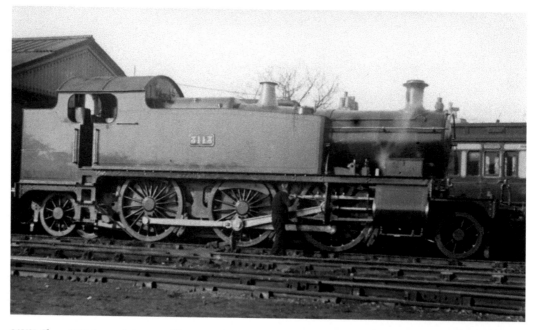

31XX Class 3113 is receiving an oiling round on the crosshead/connecting rod bearing by the driver at what is thought to be Stratford-upon-Avon with its turn-of-the-century GWR standard station building or possibly elsewhere on the North Warwickshire line, but elsewhere is not a terminus. The date is put at 1910, enough time for the station to be built and before superheating of the locomotive. MAP ?MD. (Great Western Trust)

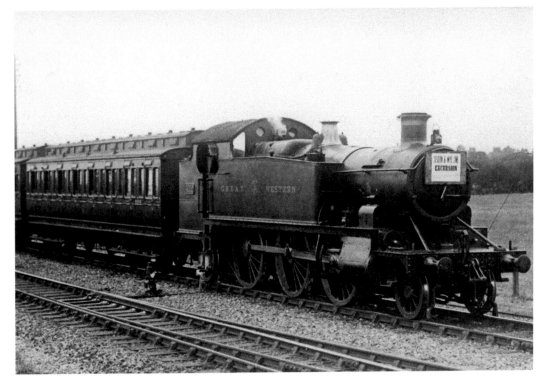

31XX numbered 3112 hauls a load of Dean clerestory coaches carrying citizens of Newport/Ebbw Vale to the Severn and Wye line of the modern-day Dean Forest Railway in 1912. The locomotive has received a superheater in 1911 but retains the toolbox over the cylinder and swan-necked front vacuum pipe as earlier features. An excursion would often have A lamps, indicating a limited-stop service. MAP K02. (Great Western Trust)

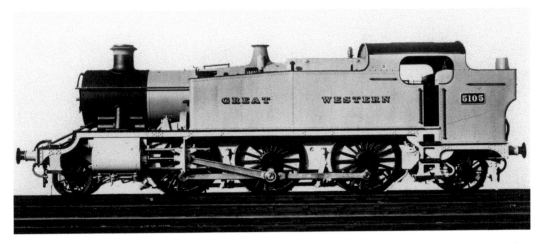

5101 Class forerunner 5105 is depicted in photographic grey livery at Swindon Works in November 1929. This was almost the final form of the large Prairie with the exception of the higher-pressure boilered 61XX in 1931 and the smaller wheeled 81XX in 1938, but these were really detail variants. These engines would not see fifty years' service as their 31XX forebears thanks to the introduction of the diesel multiple unit on suburban services in the 1950s. MAP C. (Great Western Trust)

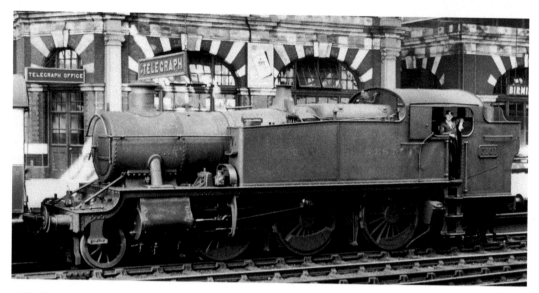

5101 Class 5101 is at Birmingham Snow Hill, whose decorative pink stonework is reminiscent of St Pancras and Great Malvern. A typical suburban passenger duty and the loco is around ten years into its working life in around 1939. MAP M. (Great Western Trust)

5101 Class 5103 is on A lamps duty at Wolverhampton Low Level while an ex-LMS Black 5 4-6-0 chuffs by on a through road. Around 1950, after which this Tyseley shed-plated loco was sent to Chester (GW) shed. MAP M. (Great Western Trust)

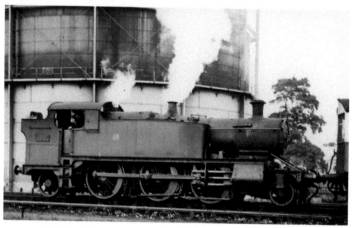

51XX Class 5117 is at Banbury coupled to an autocoach in around 1936. The loco had been converted from the 31XX Class in May 1928, but has retained the square drop end and small boiler. The art deco 1934 monogram is not in its usual place, being nearer the cab than the norm. MAP I. (Great Western Trust)

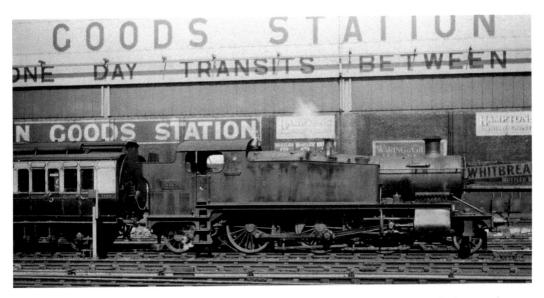

51XX Class 5119 is heading for the platforms at Paddington past the massive goods depot and seems to be on empty stock carriage shunting duties in around 1931. The clerestory coach is a member of the slip variety with additional brake cylinders on the roof and a gong at the end and not generally used on suburban trains. The loco also has no headlamp code. MAP A. (Great Western Trust)

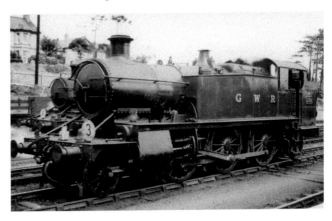

51XX Class 5132 is in surprisingly good post-war condition at Newton Abbott and it readies itself for another spell of banking duties over the South Devon banks with a colleague. It has the NA shed code above the cylinder, around 1946. MAP F. (Great Western Trust)

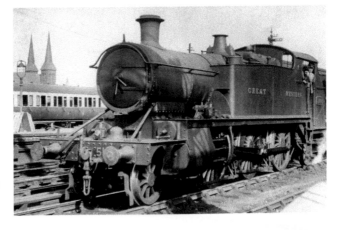

51XX Class 5148 waits at Birmingham Snow Hill on one of the through roads with another engine with light engine headcode. Dated around 1932. MAP M. (Great Western Trust)

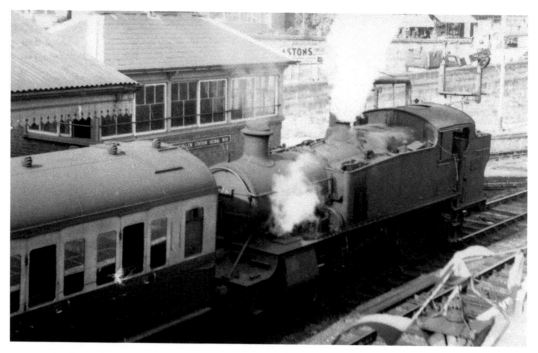

5101 Class 5176 has the road from Llangollen station signal box for a cross-country passenger train to Ruabon and Chester, the loco's home depot, in around 1950. MAP P. (Great Western Trust)

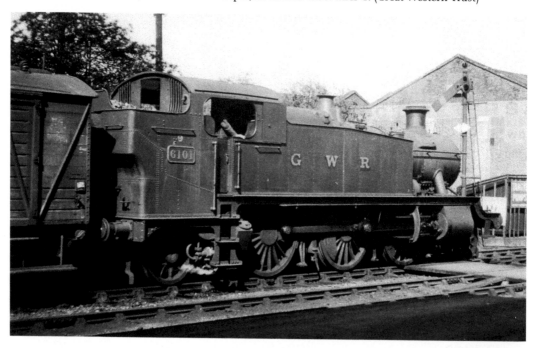

61XX Class 6101 has the 'off' from the London end of Slough station in around 1946 with a suburban passenger train. The vehicle next to the engine looks like a FRUIT D and similar vehicles were often pressed into use for parcels duties. The grills over the rear windows show they are effective in protecting the glass behind from over-enthusiastic coaling. MAP B. (Great Western Trust)

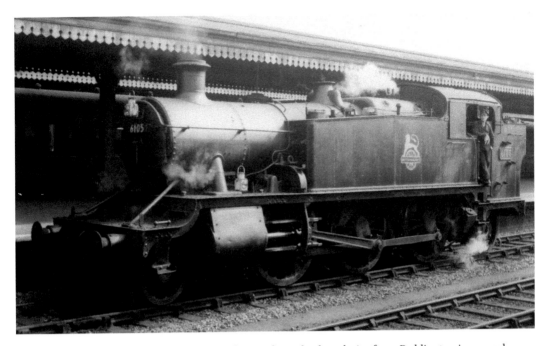

61XX Class 6105 poses at Reading, its home depot, after suburban duties from Paddington in around 1952. Locos of this class had trip gear that would operate the brakes in the event of overrunning a signal and a device to automatically clip up the ATC (AWS) gear. Both features were required when running over London Transport third rail electrified tracks. MAP C. (Great Western Trust)

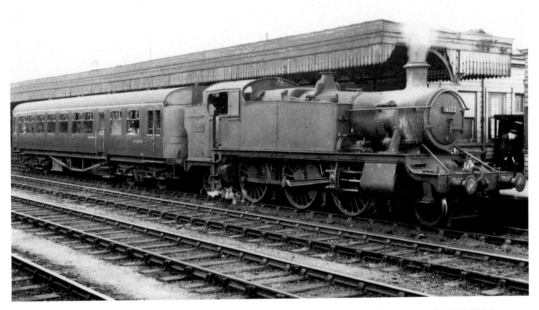

61XX Class 6122, 81F shed plate, is on the Down platform at Oxford with autocoach W236W, in around 1960. The loco has the correct headcode for an autotrain, which is the same as light engine, G, but the loco is not auto-fitted. MAP I. (Great Western Trust)

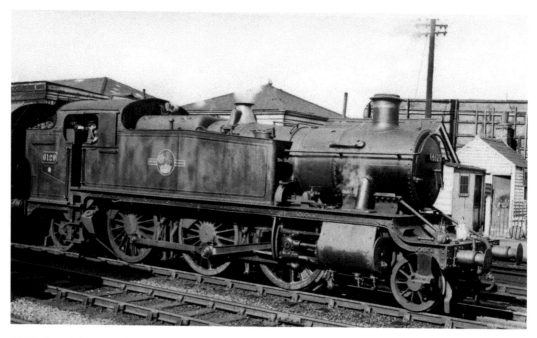

61XX Class 6129 is on the Down platform at Oxford, but this time it is an empty stock train. Likely around 1961. MAP I. (Great Western Trust)

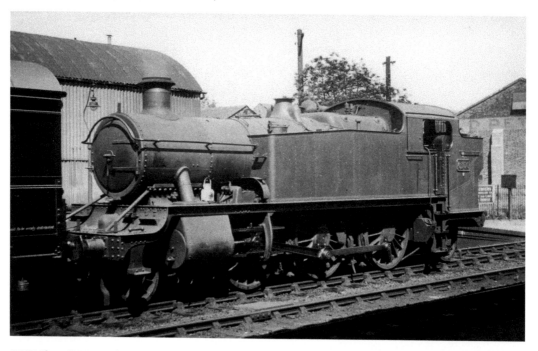

61XX Class 6156 is at the London end of Slough station. It is early BR days as the engine still carries a W suffix beneath the number plate to avoid inter-regional confusion and no smokebox door number plate brackets or plate yet, so this is, say, 1949. The van the loco is coupled to resembles an LMS type with end loading doors typically for vehicles, and evidence of this is the large round buffers with the top segment chopped off to avoid opening doors. MAP B. (Great Western Trust)

61XX Class 6158 has an 81A shed plate and is doing the job it was built for, suburban passenger out of Paddington. West Drayton and Yiewsley was the junction for the Uxbridge Vine Street and Staines branches. Around 1957. MAP B. (Great Western Trust)

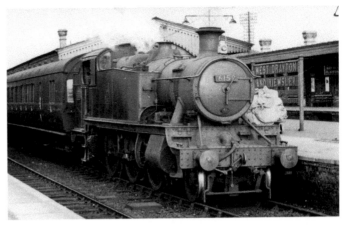

81XX Class 8100 was a Leamington engine all its life and is depicted here outside the shed in around 1939, a few months after its construction. Seen here in 1934 livery. MAP MD. (Great Western Trust)

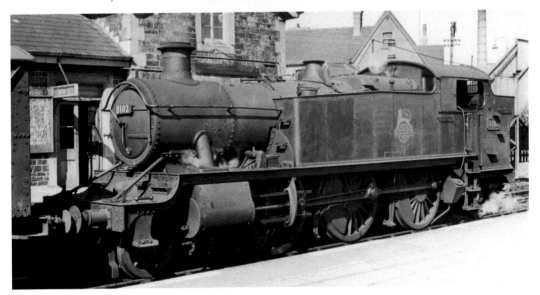

81XX Class 8102 is at Whitland in the mid-1950s bearing a Neyland shed plate and waiting to head off in the Carmarthen direction with at least a fitted van. The engine had been allocated to Whitland, a sub-shed of Neyland. MAP L. (Great Western Trust)

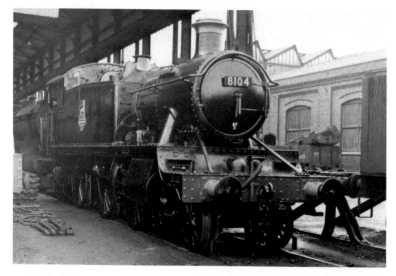

81XX Class 8104 is resplendent from the paint shop at Swindon Works in 1956 and allocated to 87A Neath (Court Sart). The depot only had 55-foot turntables so was more suited to tank engines and smaller tender engines. MAP C. (Great Western Trust)

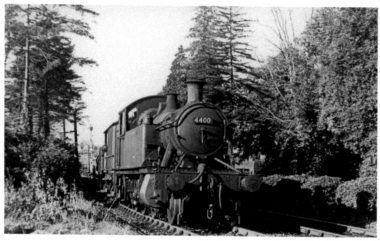

4400 has arrived at Much Wenlock with a pickup goods from Ketley and is seen here shunting on 10 September 1949. MAP N31. (Great Western Trust)

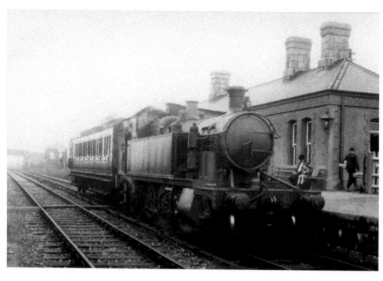

4402 has arrived at Princetown for Dartmoor Prison with a single Dean clerestory brake coach in 1931. The loco, unusually for a GWR engine, is equipped with a Westinghouse brake compressor. MAP G. (Great Western Trust)

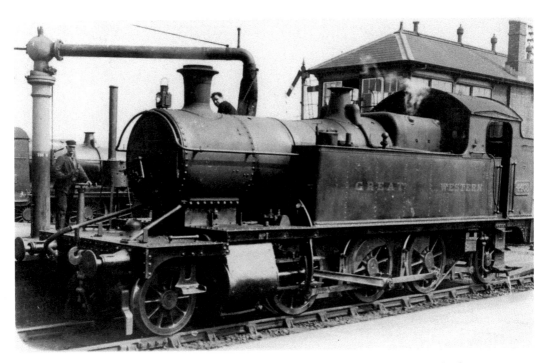

4408 is in happier times at Tondu, with the driver manning the water valve and the fireman putting the bag in. The engine is allocated to NPT (Newport) and this puts the picture at around 1920 after the garter crest was no longer used. MAP K. (Great Western Trust)

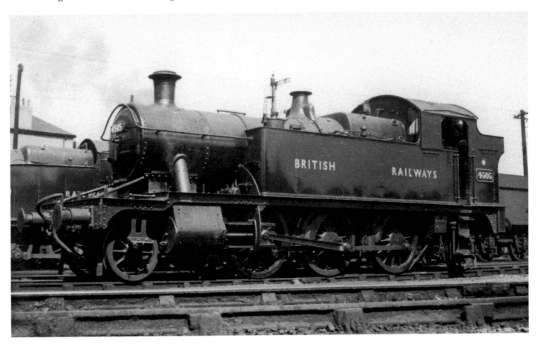

4505 has the second type of British Railways lettering, the first being in the GWR font of Egyptian Serif, but retains the shed allocation painted on above the cylinders of SBZ for ST Blazey rather than a cast shed plate. Around 1949. Map H. (Great Western Trust)

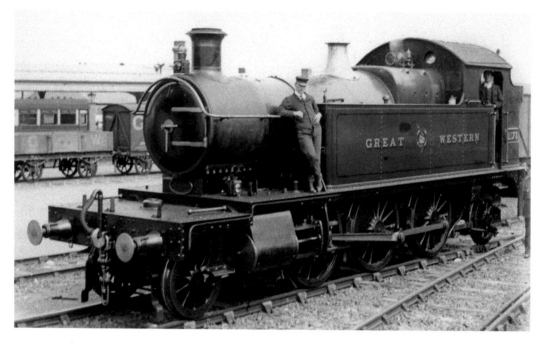

2173 is in almost new condition at its home depot of Kingsbridge in around 1908. The lined green livery with garter crest was not continued after the First World War. The loco became 4512 in December 1912 and subsequent engines had curved drop ends following the 51XX and 5101 classes. Map D. (Great Western Trust)

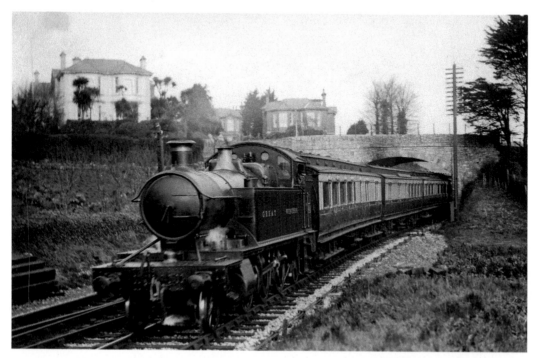

4518 is seen entering Torquay with a rake of Dean clerestory coaches in around 1920. The portholes over the firebox were plated over on some engines in later years. Map A. (Great Western Trust)

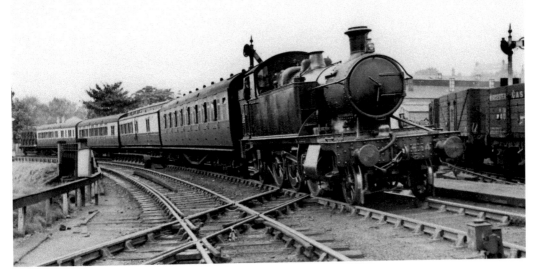

4554 arrives from the Hereford direction over the Vinegar Works branch connection at Worcester on its approach to Shrub Hill station on 8 August 1939. The coaching stock is a mix of Dean and Collett types with a CORDON at the rear. The private owner wagon to the right is inscribed 'WORCESTER GAS'. Map J52. (Great Western Trust)

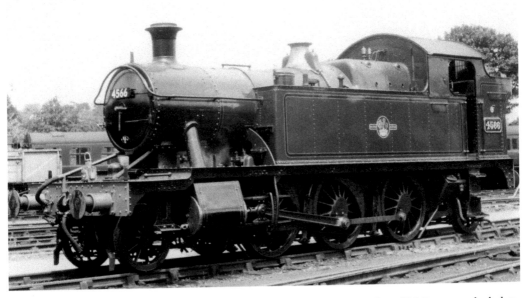

4566 is pictured at Truro in ex-works lined green BR livery in 1960 with an 83G Penzance shed plate. It was the last locomotive overhauled by Newton Abbot Works in July of that year but was withdrawn from Laira in 1962. In 2021, the loco resides in the engine house at Highley on the Severn Valley Railway. Map H. (Great Western Trust)

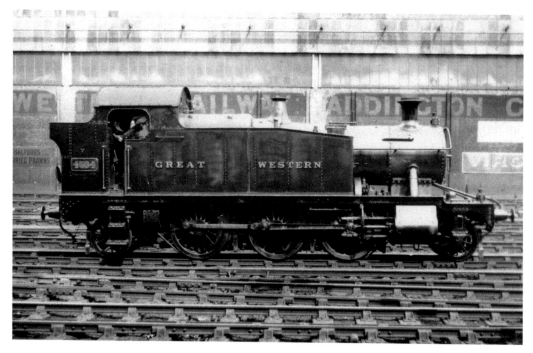

4594 is waiting for carriage shunting work at Paddington in 1928. A crew member has their feet up. One of the advertisements on Paddington goods depot proclaims 'Halford's Curried Prawns', which would have been exotic fare then. Map A. (Great Western Trust)

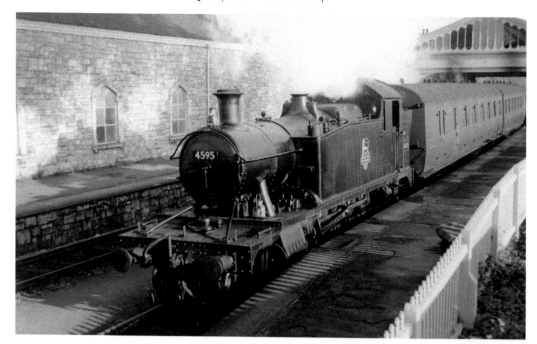

4595, a Bristol Bath Road engine, calls in at Cheddar about halfway along the Yatton to Witham branch in around 1956. One wonders if the large goods shed was so big to deal with the cheese, rather like Kidderminster's to deal with the carpets. Map D. (Great Western Trust)

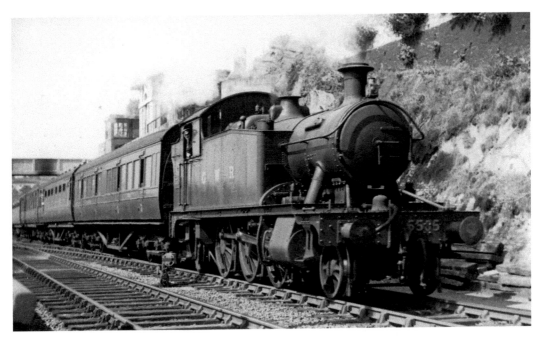

5505 has survived the Second World War in fine fettle near Dawlish on a local train in around 1946. The second coach appears to be an LMS Stanier 57-foot specimen. Map F. (Great Western Trust)

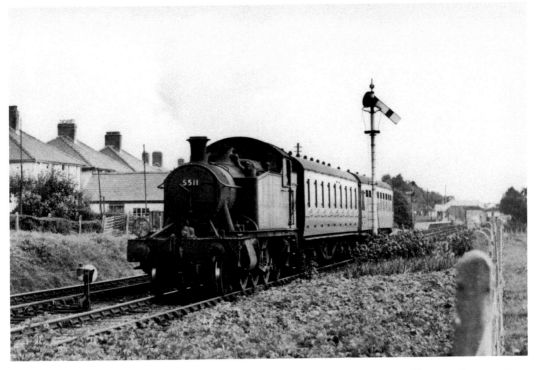

5511 is on C Auto 2 service according to the target disc, which was Cardiff Queen Street or Bute Road to Coryton. The service is portrayed in the mid-1950s and was dieselised in 1958. Map K. (Great Western Trust)

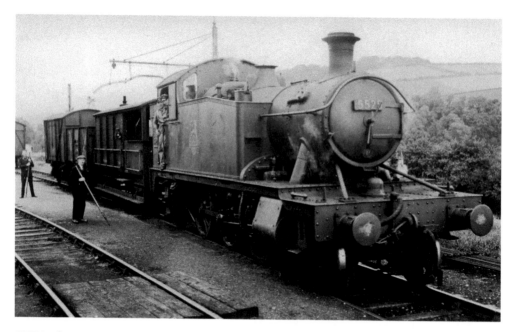

5525 is shunting a TOAD, BR 16-ton mineral wagon and a wood MINK in the yard at Dulverton in September 1951. Both members of staff on the ground have the shunting poles at the ready and the TOAD has an extra lamp shown on this side. Freights would typically have three lamps showing to the rear as a warning that the train was likely to be slow moving or stopped. The loco is allocated to 83C Exeter at this time. Map E. (Great Western Trust)

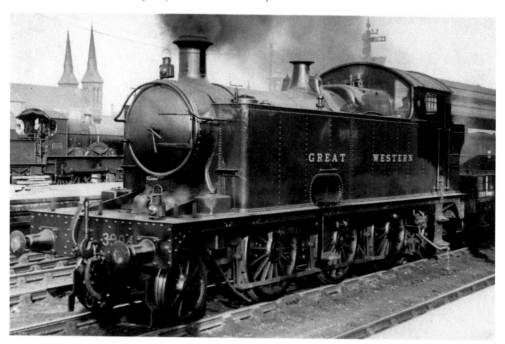

3904 after around twenty years' service on a freight on a centre road at Birmingham Snow Hill. Note the bulging cover housing the pony truck spring. The Dean Flower Class 4-4-0 4149 Auricola in the background has but a few weeks in service in 1929. Map M04. (Great Western Trust)

Table of References Used
Throughout the Book

Table Ref.	Title, Author, Publisher
	Atlas of the Great Western Railway at at 1947, R. A. Cooke (Wild Swan Pubs)
	British Railways Pre-Grouping Atlas and Gazetteer, W. P. Conolly (Ian Allan Ltd)
100	*100 Years of the Great Western*, Nicholas & Montgomery (Oxford Publishing Company – OPC)
150	*150 Great Western Railway Years*, Kevin Robertson (Kingfisher)
150G	*The Great Western Railway: 150 Glorious Years*, Pat Whitehouse, David St John Thomas (David & Charles)
362	*The Railway Magazine*, March 1962, B. W. C. Cooke (Tothill Press)
962	*The Railway Magazine*, September 1962, B. W. C. Cooke (Tothill Press)
1062	*The Railway Magazine*, October 1962, B. W. C. Cooke (Tothill Press)
1162	*The Railway Magazine*, November 1962, B. W. C. Cooke (Tothill Press)
1262	*The Railway Magazine*, December 1962, B. W. C. Cooke (Tothill Press)
ABL	*Around the Branch Lines*, Vol. 2, Chris Gammell (OPC)
ADW	*All in a Day's Work*, Tim Bryan (Ian Allan)
AHS1	*An Historical Survey of Selected GW Stations*, Vol. 1, R. H. Clark (OPC)
AHS2	*An Historical Survey of Selected GW Stations*, Vol. 2, R. H. Clark (OPC)
AHS3	*An Historical Survey of Selected GW Stations*, Vol. 3, R. H. Clark (OPC)
AHS4	*An Historical Survey of Selected GW Stations*, Vol. 4, C. R. Potts (OPC)
APR1	*A Pictorial Record of Great Western Engines*, Vol. 1, J. H. Russell (OPC)
APR2	*A Pictorial Record of Great Western Engines*, Vol. 2, J. H. Russell (OPC)
B13	*Railway Byways*, Vol. 5, Issue 8 (Irwell Press)
BBR	*Bridport Branch*, B. L. Jackson, M. J. Tattershall (OPC)
BCR	*The Banbury and Cheltenham Railway*, J. H. Russell (OPC)
BIG	*Big Four Cameraman*, R. J. Blenkinsop (OPC)
BIR	*Big Four Remembered*, J. S. Whiteley, G. W. Morrison (Bookmart Ltd)
BLB	*Branch Line Byways*, Vol. 1, G. F. Bannister (Atlantic Publishing)
BLM	*Branch Line Memories*, Vol. 1, Lewis Reade (Atlantic)

Table Ref.	Title, Author, Publisher
BLS	*Branch Lines of Somerset*, Colin Maggs (Alan Sutton Publishing)
BLT	*Great Western Branch Line Termini Combined Edition*, Paul Karau (OPC)
BRF	*British Rail in the Fifties*, Vol. 6, Western Region (Ian Allan Ltd)
BRS	*British Railways Steaming on WR* Vol. 3, Peter Hands (Defiant Publications)
CA1	*The Coast Lines of the Cambrian Railways*, Vol. 1, C. C. Green (Wild Swan Pubs)
CA2	*The Coast Lines of the Cambrian Railways*, Vol. 2, C. C. Green (Wild Swan Pubs)
CAM1	*Cambrian Railways Album*, Vol. 1, C. C. Green (Ian Allan Ltd)
CAM2	*Cambrian Railways Album*, Vol. 2, C. C. Green (Ian Allan Ltd)
CL	*Churchward Locomotives*, Brian Haresnape, Alec Swain (Ian Allan Ltd)
COLH	*Collett & Hawksworth Locomotives*, Brian Haresnape (Ian Allan Ltd)
COL3	*Colour of Steam*, Vol. 3, P. B. Whitehouse (Atlantic Publishing)
CRPS	*Cornwall's Railways Pictorial Survey*, Anthony Fairclough (Bradford Barton)
CRO	*Cheshire Railways in Old Photographs*, Mike Hitches (Sutton Publishing)
CS1	*GWR Country Stations*, Chris Leigh (Ian Allan Ltd)
CS2	*GWR Country Stations*, Vol. 2, Chris Leigh (Ian Allan Ltd)
E160	*Great Western Echo*, No. 160, Michael H. C. Baker (GWS Ltd)
E211	*Great Western Echo*, No. 211, Adrian Knowles (GWS Ltd)
E212	*Great Western Echo*, No. 212, Adrian Knowles (GWS Ltd)
E214	*Great Western Echo*, No. 214, Adrian Knowles (GWS Ltd)
E220	*Great Western Echo*, No. 220, Adrian Knowles (GWS Ltd)
E222	Great Western Echo Number 222, Adrian Knowles, GWS Ltd
E224	*Great Western Echo*, No. 224, Adrian Knowles (GWS Ltd)
E225	*Great Western Echo*, No. 225, Adrian Knowles (GWS Ltd)
EGW	*Echoes of the Great Western*, R. J. Blenkinsop (OPC)
FIR	*Firing Days: Reminiscences of a Great Western Fireman*, Harold Gasson (OPC)
FOR	*Forgotten Railways: South Wales*, James Page (David & Charles)
GBL	*Great Western Branch Lines -2*, Michael S. Welch (Runpast Publishing)
GBLG	*Great Western Branch Lines 1955–1965*, C. J. Gammell (OPC)
GC	*GWR Journal Special Cornish Issue*, John Copsey (Wild Swan Pubs)
GCU	*Great Western Steam In Close Up*, Peter W. B. Semmens (Bradford Barton)
GDG	*The Great Days of the GWR*, David St John Thomas, Patrick Whitehouse (BCA)
GDW	*Glory Days, Western Signalman*, Adrian Vaughan (Ian Allan Ltd)
GH	*Great Western Railway Handbook*, B. K. Cooper (Ian Allan Ltd)
GMT	*The GWR Mixed Traffic 4-6-0 Classes*, O. S. Nock (Ian Allan Ltd)
GP3	*Great Western Pictorial*, No. 3, Tony & Sue Sterndale (Wild Swan Pubs)
GSS	*Great Western Steam South of the Severn*, R. E. Toop (Bradford Barton)
GST	*Great Western Steam*, W. A. Tuplin (George Allen & Unwin Ltd)
GW1	*Great Western Album*, R. C. Riley (Ian Allan Ltd)
GW2	*Great Western Album*, No. 2, R. C. Riley (Ian Allan Ltd)
GWW	*The Great Western at Work 1921–1939*, Adrian Vaughan (Patrick Stephens Ltd)
G2	*Great Western Railway Journal*, No. 2, John Copsey (Wild Swan Pubs)
G4	*Great Western Railway Journal*, No. 4, John Copsey (Wild Swan Pubs)

Table Ref.	Title, Author, Publisher
G5	*Great Western Railway Journal*, No. 5, John Copsey (Wild Swan Pubs)
G10	*Great Western Railway Journal*, No. 10, John Copsey (Wild Swan Pubs)
G11	*Great Western Railway Journal*, No. 11, John Copsey (Wild Swan Pubs)
G13	*Great Western Railway Journal*, No. 13, John Copsey (Wild Swan Pubs)
G14	*Great Western Railway Journal*, No. 14, John Copsey (Wild Swan Pubs)
G15	*Great Western Railway Journal*, No. 15, John Copsey (Wild Swan Pubs)
G16	*Great Western Railway Journal*, No. 16, John Copsey (Wild Swan Pubs)
G17	*Great Western Railway Journal*, No. 17, John Copsey (Wild Swan Pubs)
G19	*Great Western Railway Journal*, No. 19, John Copsey (Wild Swan Pubs)
G20	*Great Western Railway Journal*, No. 20, John Copsey (Wild Swan Pubs)
G23	*Great Western Railway Journal*, No. 23, John Copsey (Wild Swan Pubs)
G26	*Great Western Railway Journal*, No. 26, John Copsey (Wild Swan Pubs)
G27	*Great Western Railway Journal*, No. 27, John Copsey (Wild Swan Pubs)
G30	*Great Western Railway Journal*, No. 30, John Copsey (Wild Swan Pubs)
G31	*Great Western Railway Journal*, No. 31, John Copsey (Wild Swan Pubs)
G32	*Great Western Railway Journal*, No. 32, John Copsey (Wild Swan Pubs)
G33	*Great Western Railway Journal*, No. 33, John Copsey (Wild Swan Pubs)
G34	*Great Western Railway Journal*, No. 34, John Copsey (Wild Swan Pubs)
G36	*Great Western Railway Journal*, No. 36, John Copsey , Wild Swan Pubs
G37	*Great Western Railway Journal*, No. 37, John Copsey (Wild Swan Pubs)
G38	*Great Western Railway Journal*, No. 38, John Copsey (Wild Swan Pubs)
G39	*Great Western Railway Journal*, No. 39, John Copsey (Wild Swan Pubs)
G40	*Great Western Railway Journal*, No. 40, John Copsey (Wild Swan Pubs)
G41	*Great Western Railway Journal*, No. 41, John Copsey (Wild Swan Pubs)
G43	*Great Western Railway Journal*, No. 43, John Copsey (Wild Swan Pubs)
G45	*Great Western Railway Journal*, No. 45, John Copsey (Wild Swan Pubs)
G49	*Great Western Railway Journal*, No. 49, John Copsey (Wild Swan Pubs)
G50	*Great Western Railway Journal*, No. 50, John Copsey (Wild Swan Pubs)
G51	*Great Western Railway Journal*, No. 51, John Copsey (Wild Swan Pubs)
G52	*Great Western Railway Journal*, No. 52, John Copsey (Wild Swan Pubs)
G54	*Great Western Railway Journal*, No. 54, John Copsey (Wild Swan Pubs)
G55	*Great Western Railway Journal*, No. 55, John Copsey (Wild Swan Pubs)
G57	*Great Western Railway Journal*, No. 57, John Copsey (Wild Swan Pubs)
G58	*Great Western Railway Journal*, No. 58, John Copsey (Wild Swan Pubs)
G59	*Great Western Railway Journal*, No. 59, John Copsey (Wild Swan Pubs)
G61	*Great Western Railway Journal*, No. 61, John Copsey (Wild Swan Pubs)
G62	*Great Western Railway Journal*, No. 62, John Copsey (Wild Swan Pubs)
G64	*Great Western Railway Journal*, No. 64, John Copsey (Wild Swan Pubs)
G65	*Great Western Railway Journal*, No. 65, John Copsey (Wild Swan Pubs)
G68	*Great Western Railway Journal*, No. 68, John Copsey (Wild Swan Pubs)
G69	*Great Western Railway Journal*, No. 69, John Copsey (Wild Swan Pubs)
G70	*Great Western Railway Journal*, No. 70, John Copsey (Wild Swan Pubs)

Table Ref.	Title, Author, Publisher
G71	*Great Western Railway Journal*, No. 71, John Copsey (Wild Swan Pubs)
G73	*Great Western Railway Journal*, No. 73, John Copsey (Wild Swan Pubs)
G74	*Great Western Railway Journal*, No. 74, John Copsey (Wild Swan Pubs)
G75	*Great Western Railway Journal*, No. 75, John Copsey (Wild Swan Pubs)
G76	*Great Western Railway Journal*, No. 76, John Copsey (Wild Swan Pubs)
G77	*Great Western Railway Journal*, No. 77, John Copsey (Wild Swan Pubs)
G78	*Great Western Railway Journal*, No. 78, John Copsey (Wild Swan Pubs)
G79	*Great Western Railway Journal*, No. 79, John Copsey (Wild Swan Pubs)
G80	*Great Western Railway Journal*, No. 80, John Copsey (Wild Swan Pubs)
G81	*Great Western Railway Journal*, No. 81, John Copsey (Wild Swan Pubs)
G82	*Great Western Railway Journal*, No. 82, John Copsey (Wild Swan Pubs)
G84	*Great Western Railway Journal*, No. 84, John Copsey (Wild Swan Pubs)
G85	*Great Western Railway Journal*, No. 85, John Copsey (Wild Swan Pubs)
G86	*Great Western Railway Journal*, No. 86, John Copsey (Wild Swan Pubs)
G87	*Great Western Railway Journal*, No. 87, John Copsey (Wild Swan Pubs)
G88	*Great Western Railway Journal*, No. 88, John Copsey (Wild Swan Pubs)
G89	*Great Western Railway Journal*, No. 89, John Copsey (Wild Swan Pubs)
G90	*Great Western Railway Journal*, No. 90, John Copsey (Wild Swan Pubs)
G91	*Great Western Railway Journal*, No. 91, John Copsey (Wild Swan Pubs)
G92	*Great Western Railway Journal*, No. 92, John Copsey (Wild Swan Pubs)
G93	*Great Western Railway Journal*, No. 93, John Copsey (Wild Swan Pubs)
G94	*Great Western Railway Journal*, No. 94, John Copsey (Wild Swan Pubs)
G95	*Great Western Railway Journal*, No. 95, John Copsey (Wild Swan Pubs)
G96	*Great Western Railway Journal*, No. 96, John Copsey (Wild Swan Pubs)
G97	*Great Western Railway Journal*, No. 97, John Copsey (Wild Swan Pubs)
G99	*Great Western Railway Journal*, No. 99, John Copsey (Wild Swan Pubs)
G101	*Great Western Railway Journal*, No. 101, John Copsey (Wild Swan Pubs)
G103	*Great Western Railway Journal*, No. 103, John Copsey (Wild Swan Pubs)
GW4	*Great Western Steam in Action*, Vol. 4, L. M. Collins (Bradford Barton)
GW5	*Great Western Steam in Action*, Vol. 5, L. M. Collins (Bradford Barton)
GW6	*Great Western Steam in Action*, Vol. 6, L. M. Collins (Bradford Barton)
GWU	*Great Western Steam in Close-Up*, Peter W. B. Semmens (Bradford Barton)
GWC	*Great Western Steam Through the Cotswolds*, Colin L. Williams (Bradford Barton)
GWY	*Great Western Steam Through the Years*, Fairclough & Wills (Bradford Barton)
GWY2	*Great Western Steam Through the Years 2*, Fairclough & Wills (Bradford Barton)
GWM	*Great Western Steam Miscellany*, Vol. 2, 5079 Lysander (Bradford Barton)
GWM3	*Great Western Steam Miscellany*, Vol. 3, 5079 Lysander (Bradford Barton)
GWR	*The Great Western Remembered*, J. S. Whiteley & G. W. Morrison (OPC)
GWS	*Great Western Steam*, Buckley & Dickson (The History Press)
GWS2	*Great Western Steam Through the Years*, Vol. 2, Fairclough & Wills (Bradford Barton)
GWSB	*Great Western Steam Around Bristol*, Colin L. Williams (Bradford Barton)
GWJ	*GWR Junction Stations*, Adrian Vaughan (Ian Allan)

Table Ref.	Title, Author, Publisher
GWL	*Great Western in Cornwall*, Fairclough & Butt (Bradford Barton)
GWE	*Great Western Steam on Shed*, Colin L. Williams (Bradford Barton)
GWRB	*GWR Branch Lines*, C. J. Gammell (OPC)
GWV	*Great Western Steam in the West Country*, Mike Arlett & David Lockett (OPC)
GWW	*The Great Way West*, David St John Thomas (David and Charles)
GWX	*Great Western Steam in Wales and the Border Counties*, Colin L. Williams (Bradford Barton)
HIS	*An Historical Survey: GWR Engine Sheds 1947*, E. Lyons (OPC)
HGW	*The Heart of the Great Western*, Adrian Vaughan (Silver Link Publishing)
KB	*The Kingsbridge Branch*, Ken Williams & Dermot Reynolds (OPC)
LB	*Branch Line Britain*, Paul Atterbury (David & Charles)
LBR	*Locomotives of British Railways*, Casserley & Asher (Spring Books)
LS1	*Loco Spotters Annual 1961*, Cecil J. Allen (Ian Allan Ltd)
LS3	*Loco Spotters Annual 1963*, Cecil J. Allen (Ian Allan Ltd)
LLW	*Lost Lines Western*, Nigel Wellbourn (Ian Allan Ltd)
MAR	*Marcher Railways*, Bodlander, Hambly, Leadbetter, Southern (Bridge Books)
MBL	*Mapping Britain's Lost Branch Lines*, Paul Atterbury (David & Charles)
MGW	*More Last Days of Steam in Oxfordshire*, Laurence Waters (Alan Sutton)
NOS	*The Nostalgia of Steam*, John Spencer Gilkes (Silver Link Publications)
NW1	*The North & West Route*, Vol. 1, John Hodge (Wild Swan Publications)
NW2	*The North & West Route*, Vol. 2, John Hodge (Wild Swan Publications)
NW3A	*The North & West Route*, Vol. 3A, John Hodge (Wild Swan Publications)
NW3B	*The North & West Route*, Vol. 3B, John Hodge (Wild Swan Publications)
OBD	*Obstruction Danger*, Adrian Vaughan (Patrick Stephens Ltd)
OSW	*Oswestry Railways*, Bodlander, Hambly, Leadbetter (Southern, Bridge Books)
PVSL	*GWR Two Cylinder Piston Valve Steam Locomotives*, E. J. Nutty (EJ Nutty)
PWR	*A Portrait of Wirral's Railways*, Roger Jermy (Countryvise Ltd)
RC5	*Rail Centres: Exeter*, No. 5, Colin G. Maggs (Booklaw Publications)
RC9	*Rail Centres: Reading*, No. 9, Laurence Waters (Booklaw Publications)
RCS	*Rail Centres: Shrewsbury*, No. 10, Richard K. Morriss (Booklaw Publications)
RCR	*Rail Centres: Reading*, No. 14, Laurence Waters (Booklaw Publications)
RCT5	*The Locomotives of the Great Western Railway*, Part 5 (RCTS)
RCT9	*The Locomotives of the Great Western Railway*, Part 9 (RCTS)
REF	*GWR Reflections*, Beck & Harris (Silver Link Publishing)
RR	*Railway Roundabout*, Rex Christiansen, John Adams (Ian Allan)
RTB	*Rails Through Bala*, Bodlander, Hambly, Leadbetter (Southern, Bridge Books)
SAL	*Salute to the Great Western*, Cecil J. Allen (Ian Allan)
SAR	*Shropshire Railways*, Geoff Cryer (The Crowood Press)
SCE	*The Great Western Scene*, Maurice Earley (OPC)
SCP	*Steam Colour Portfolio*, Vol. 1, Keith Pirt (Booklaw Publications)
SDN	*Great Western: Swindon*, Robin Jones (Mortons Media Group Ltd)
SGW	*Shadows of the Great Western*, R. J. Blenkinsop (OPC)

Table Ref.	Title, Author, Publisher
SPI	*Spirit of the Great Western*, Mike Esau (OPC)
SSW	*Summer Saturdays in the West*, David St John Thomas, Simon Rocksborough Smith (David and Charles)
STW3	*British Railways Steaming on the Western Region*, Vol. 3, Peter Hands (Defiant)
SWC	*Steam in West Cheshire and North Wales*, S. D. Wainwright (Ian Allan)
SWS	*Steam Between Swindon and the Severn*, Mike Arlett, David Lockett (Ian Allan)
TC	*The Great Western at the Turn of the Century*, A. R. Kingdom (OPC)
TDH	*The Day of the Holiday Express*, Richard Woodley (Ian Allan)
TFL	*The Final Link*, Dennis Edwards, Ron Pigram (Midas Books)
TGM	*The Great Western in Mid Cornwall*, Alan Bennett (Kingfisher Railway Prod.)
TGT	*The GWR Then and Now*, Laurence Waters (Book Club Associates)
TGW	*The Great Western Remembered*, J. S. Whiteley & G. W. Morrison (OPC)
TGY	*The Golden Years British Steam Trains GWR*, Colin Garratt (Milepost 92½)
TRI	*Great Western Tribute*, Michael H. C. Baker (Ian Allan Ltd)
TRM	*The Railway Magazine*, November 2020, Chris Milner (Morton's Media)
TRU	*Truly the Great Western*, Maurice Earley (OPC)
TGS	*The Great Western at Swindon Works*, Alan S. Peck (OPC)
TVL	*The Teign Valley Line*, L. W. Pomroy (OPC)
VoR	*The Vale of Rheidol Light Railway*, C. C. Green (Wild Swan Publications)
W30	*The Great Western Railways in the 1930s*, Fraser, Geen, Scott (Kingfisher)
W32	*The Great Western Railways in the 1930s*, Vol. 2, Geen, Scott (Kingfisher)
WELP	*Welsh Railways – A Photographer's View*, Dunstone & Jarvis (Gomer Press)
WES	*Western Steam in Colour 2*, Hugh Ballantyne (Ian Allan)
WGW	*West Gloucester & Wye Valley Lines*, Vol. 1, Neil Parkhouse (Lightmoor Press)
WGS	*West Gloucester and Wye Valley Lines Supplement*, Neil Parkhouse (Lightmoor Press)
WMI	*The Great Western in the West Midlands*, P. B. Whitehouse (OPC)
WML	*The West Midlands Lines of the GWR*, Keith M. Beck (Ian Allan Ltd)
WS	*Western Signalman*, Adrian Vaughan (Ian Allan Ltd)
WSF	*Western Steam Farewell*, Darren Page (Ian Allan Ltd)
WWG	*Window on the Great Western*, M. F. Yarwood (Wild Swan Publications)
YB	*The Yealmpton Branch*, A. R. Kingdom (OPC)
ZEN	*Great Western Steam at its Zenith*, Brian Stephenson (Ian Allan Ltd)

Glossary of Terms and Abbreviations

For abbreviated GWR engine shed names, please see separate table.

Abbreviation	Full Expression
BR	British Railways, later British Rail
B set	A GWR pair/4 of similar coaches with brake ends, coupled
b&c	Blood and custard, aka carmine and cream, BR 1950s livery
BTM	Bristol Temple Meads station
CLC	Cheshire Lines Committee; GC, GN & Midland Railway Joint
CORDON	GWR Telegraphic code name for coal gas tank wagon
CS	Carriage sidings
DH	Two engines on a train together at front, double headed
DN&SR	Didcot Newbury and Southampton Railway (GWR branch)
FRUIT	GWR Telegraphic code name for a covered fruit van
GCR	Great Central Railway, LNER constituent
GNR	Great Northern Railway, LNER constituent
HCRS	Home Counties Railway Society
LCGB	Locomotive Club of Great Britain
L&NWR	London & North Western Railway, later part of LMS Railway
L&SWR	London & South Western Railway, later Southern Railway
LOCO	GWR Telegraphic code name, locomotive coal wagon
M&SWJR	Midland and South Western Junction Railway (GWR branch)
MEX	GWR Telegraphic name for a livestock/cattle van
MICA	GWR Telegraphic name for an insulated meat van
MINK	GWR Telegraphic code for a covered van, wood or iron
MPD	Motive Power Depot
NR	Plymouth North Road GWR station, LSWR/SR – Friary
OPC	Oxford Publishing Company

Abbreviation	Full Expression
OURS	Oxford University Railway Society
PILOT	An engine attached at the front of a train for assistance
PRC	Plymouth Railway Circle
PRESFLO	British Railways pressurised discharge cement wagon
RCTS	Railway Correspondence and Travel Society
REC	Railway Enthusiasts Club
S&DJR	Somerset & Dorset Joint Railway
SE&CR	South Eastern & Chatham Railway
SHARK	Brake van used to formate with ballast wagons
SIPHON	GWR Telegraphic code name, milk churn wagon/parcels
SLS	Stephenson Locomotive Society
SHOCVAN	BR covered van with shock absorbers for fragile loads
SM	Stationmaster
SR	Southern Railway or Southern Region, contextual
stn	Station environs rather than at a platform
TOAD	GWR Telegraphic code name for a brake van
TRPS	Talyllyn Railway Preservation Society
WSH	Worcester Shrub Hill station